POSTCARD HISTORY SERIES

Allentown

Greetings from ALLENTOWN PA.

The vintage postcards offered on the following pages help tell the story and history of Allentown Pennsylvania. Each of the landmarks presented in this book played a role in shaping Allentown into the city it is today. This book will offer old time residents a chance to reminisce about old times and people new to Allentown an opportunity to learn sometime new about the historic landmarks they pass everyday.

On the front cover: (Courtesy of the author's collection.)

On the back cover: The stately Old Lehigh County Courthouse was built in 1819. As designed by Allentown's leading architect, Gustavus Adolphus Aschbach, the courthouse presents a dignified appearance worthy of the solemn proceedings that took place within. This postcard shows the results of an 1864 renovation that added a copula and improved façade. The postcard is dated by the 1920 era cars parked on the street and the presence of the building behind the courthouse which was an addition added in 1915.(Courtesy of the author's collection.)

POSTCARD HISTORY SERIES

Allentown

Kevin S. Gildner

ARCADIA

Published by Arcadia Publishing
Charleston SC, Chicago IL, Portsmouth NH, San Francisco CA

Printed in Great Britain

Library of Congress Catalog Card Number: 2005934586

For all general information contact Arcadia Publishing at:
Telephone 843-853-2070
Fax 843-853-0044
E-mail sales@arcadiapublishing.com
For customer service and orders:
Toll-Free 1-888-313-2665

Visit us on the Internet at http://www.arcadiapublishing.com

*I would like to thank my parents, who instilled in me
the pride of one's hometown, and my children,
who taught me that learning is a lifetime endeavor.*

CONTENTS

I CAN'T HELP THINKING YOU SHOULDT BE IN

ALLENTOWN, PA.

VERE ALL GOOT PEOPLES ISS.

This postcard, mailed in 1912, pokes fun at the Pennsylvania German accent. During colonial times, Germans were the predominant ethnic group in Pennsylvania. William Penn and his family wanted people to settle his colony. He found willing takers in the people of Germany, who wanted to escape wars and religious persecution. The Germans brought with them their religion, culture, and values. Later, people from Ireland, Italy, the Middle East, Latin America, and other parts of the world also came to Allentown in search of the American dream. Each group brought something unique, making Allentown a better place to live.

INTRODUCTION

In 1735, William Allen, a wealthy and influential businessman from Philadelphia, purchased 5,000 acres of land near the confluence of the Lehigh River and the Jordan and Little Lehigh Creeks. At the time of his purchase, thousands of mainly German immigrants were coming to Pennsylvania, and many would settle in the Lehigh Valley. For the most part, the German immigrants were farmers who found in the Lehigh Valley the same rich soil and climate they left behind. With continued immigration and growth, it was apparent that a market town was needed. In 1761, William Allen fulfilled this need by setting aside 700 acres to establish a new town he called Northampton. The name was changed to Allentown in 1838. Construction of the first houses in what eventually became Allentown started in 1762.

During the first half of the 19th century, Allentown remained a small market town. The town's population would expand in the years before and after the Civil War. The main reason for this explosion in growth was the movement of people from the countryside to work in the new industries springing up along the Lehigh River. Soon the availability of jobs also attracted mainly Irish immigrants. Iron mills, foundries, and other iron-related factories built facilities in Allentown and other nearby towns. To be successful, this heavy industry needed a cheap and reliable transportation system to haul the raw materials and finished products. At first, the nearby Lehigh Canal served this purpose. The canal was built to haul anthracite coal from northeast Pennsylvania to market. The same canal was put to use serving Allentown's new industry. So despite being an inland city on a relatively small river, Allentown owes its industrial beginning to water transportation. Soon afterward, two railroad companies, Lehigh Valley and Central Railroad of New Jersey, built lines into Allentown. Both would build ornate and functional passenger stations on lower Hamilton Street. Allentown continued to prosper and grow in the years immediately after the Civil War. However, the panic of 1873 and the depression that followed proved devastating to the iron industry.

Allentown was the destination for immigrants looking for a better life and finding it in the form of employment in one of Allentown's many mills and factories. First came the Irish, followed by Italians and other people from Europe. Each of the groups brought with them their customs, making Allentown a better and more interesting place to live. While English was the language of business in Allentown, German was spoken around town well into the late 19th century. During the 20th century, other groups would come from Syria, Latin America, Eastern Europe, and other parts of the globe. One thing that has not changed about Allentown is that it remains a city of immigrants.

The people of Allentown who today enjoy the city parks owe a debt of gratitude to General Harry Trexler. However, the general was pulled somewhat reluctantly into the role of benefactor of the city parks. In the early 1900s, the city owned a vacant lot in the rapidly developing west end. The land was originally procured as a good location for a reservoir. The reservoir was never built, and the land sat idle. About this time, it was discovered that a south Allentown real estate company in which General Trexler had a financial interest was receiving water from the city without paying for it. The mayor of Allentown, Fred Lewis, called Trexler into his office and demanded payment. General Trexler denied any knowledge of this alleged oversight. As a compromise, Trexler offered to pay the city for the water with the condition that the money be used to develop a park at the site where the reservoir was to be built. When it opened on September 17, 1908, the park was simply named West Park and Allentown's park system was born. Even after his debt to the city was paid, General Trexler continued to donate land and money for parks. Upon his death, the Trexler Foundation was established, with the purpose of providing funds for new parks, recreation programs, and property upkeep. The foundation he established has kept alive his vision of a world-class park system in his hometown.

In the late 1920s, the city appeared at the dawn of prosperity. The city was getting ready to celebrate reaching the 100,000 level in population, and the first true skyscraper, the Pennsylvania Power and Light (PP&L) Building, was constructed. Predictions of reaching 200,000 in the next 20 years were made. As it turned out, the celebration of reaching 100,000 was premature, and the city's population would plateau at about 105,000. In addition, the PP&L Building would remain the city's only true skyscraper to this day.

At the same time Allentown was coming of age as a legitimate city, postcards became popular. In the days before computers and even telephones, postcards were a cheap way to send messages. For the small price of a postcard and only a penny for a stamp, people could send a message anywhere in the country. The photographers and artists captured the charm and character of what makes Allentown unique. The postcards also let us know today what was important to the people of Allentown almost 100 years ago. Today, driving past the same landmarks featured in the vintage postcards of this book, it may be hard to understand what made them so special that they warrant a postcard. The vintage postcards shown in his book offer the reader a chance to see the landmarks by themselves, without the clutter of a busy city. Each postcard captures a piece of history. The old postcard makers captured not only the charm and beauty of the city but also its hardworking gritty side. It is hoped by the author that the vintage postcards offered in this little book trigger for the reader a nostalgic look back at fond memories from times gone by.

One

BUSINESS AND INDUSTRY

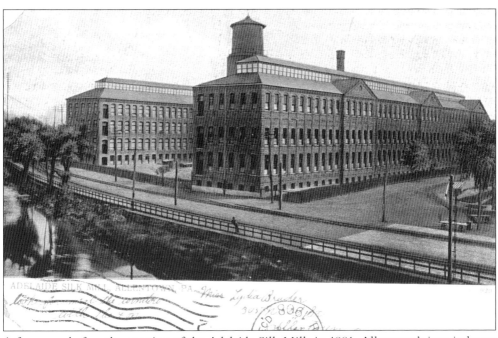

A few years before the opening of the Adelaide Silk Mills in 1881, Allentown's iron industry collapsed, leaving the city economically depressed. To prevent this from happening again, efforts were made to develop a diversified industrial base. Convincing the Phoenix Manufacturing Company to open a silk mill in Allentown was the first major success of that effort. In his speech at the opening of the mill, Mayor Edwin G. Martin boasted of the many advantages Allentown had to offer industries. Among the advantages were cheap transportation, cheap energy costs, proximity to major cities of the Northeast, clean water, and "the thousands of unemployed girls and boys of our city." These same benefits would continue to lure industries to locate to Allentown for the next century. However, local leaders would change the term unemployed children to a skilled and dedicated workforce.

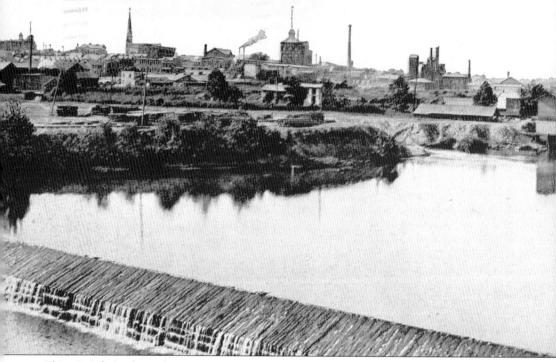

Lehigh River from bridge, Allentown, Pa.

This view from the early 1900s shows the west bank of the Lehigh River and the area known as Lehigh Port. During its heyday, Lehigh Port was a bustling industrial center. In its prime, Lehigh Port could boast of the some of the nation's most modern iron foundries.

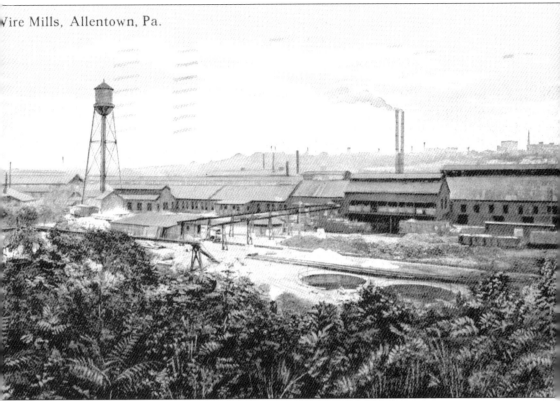

Allentown gained another major industrial employer when the Iowa Barb Wire Company located its eastern plant in the city. The mill opened in 1886 and would eventually produce up to 100,000 tons of barbed wire, nails, and staples per year. The U.S. Army was a major customer of the mill's barbed wire during World War I. The plant remained in operation until 1943. The facility would become an eyesore and eventually be torn down in the redevelopment boom of the 1960s.

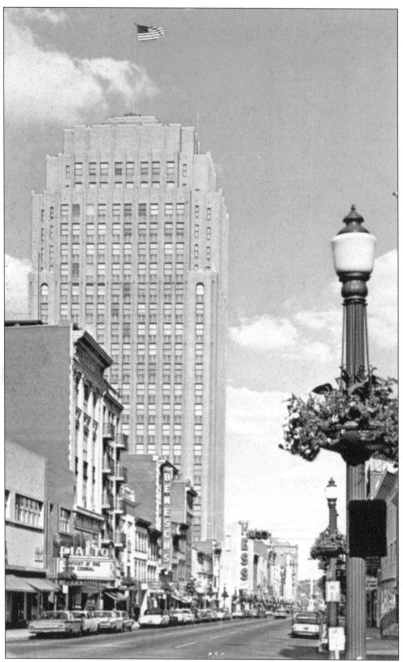

Thanks in part to General Henry Trexler, Pennsylvania Power and Light (PP&L), a young company in the new and expanding power industry, was persuaded to locate its headquarters building in downtown Allentown. The building has dominated the skyline of Allentown ever since its completion in June of 1928. As envisioned by the architects, the building's design was intended to give the impression of luxury and prosperity. This postcard shows three items that are unique to Allentown; in the foreground is a distinctive flower stand/light post, the tall PP&L Building, and in the distance, the Hess Brothers department store. The sign for the movie *Gunfight at the OK Corral* dates this photograph to 1957.

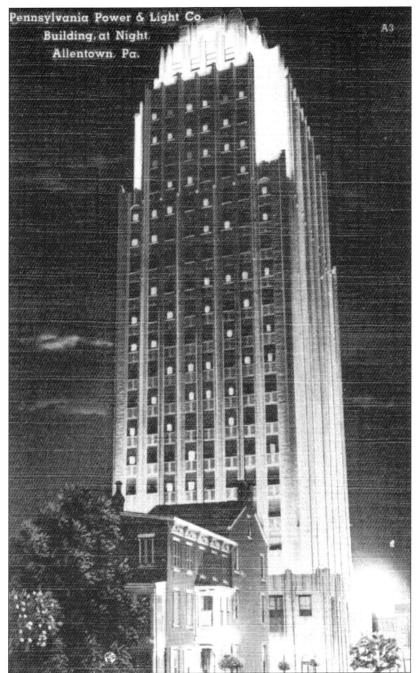

Pennsylvania Power & Light Co. Building, at Night. Allentown, Pa.

A3

As shown in this postcard, the brilliantly illuminated Pennsylvania Power and Light Building has served as a beacon to the people of Allentown for almost 80 years. To this day, the Pennsylvania Power and Light Building remains Allentown's tallest building. At the time of the building's completion, Allentown's population was approaching 100,000. Predictions were made that the city would reach 200,000 within the next 25 years. However, a celebration in 1929 in honor of this milestone turned out to be a bit premature. Allentown's population would plateau at a little over 100,000, and never again would a tall building such as the PP&L be built in Allentown.

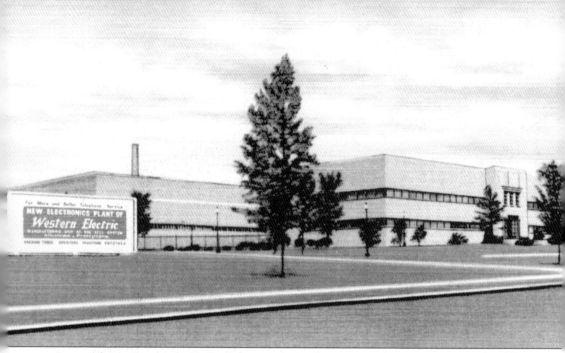

Opened for production in November 1947, the new Western Electric plant made vacuum tubes, transistors, and other communication equipment for Bell Systems. Initial employment at the facility was about 1,500 people and grew to over 3,000 in six years. Over the years, Western Electric would provide well paying jobs to tens of thousands of people from all over the Lehigh Valley.

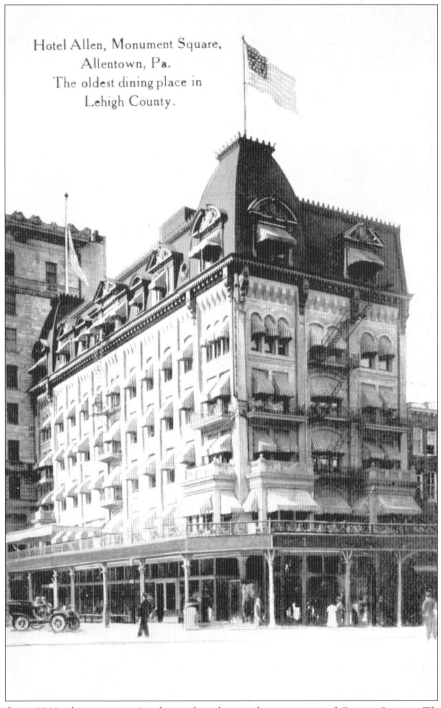

Hotel Allen, Monument Square,
Allentown, Pa.
The oldest dining place in
Lehigh County.

As early as 1810, there was an inn located at the northeast corner of Center Square. The first inn at this location was run by George Savitz, who was also the first postmaster of Allentown. Hotel Allen, pictured here, was opened in 1891 and remained Allentown's preeminent hotel for many years. In the 1950s, Hotel Allen was torn down and replaced with the First National Bank of Allentown.

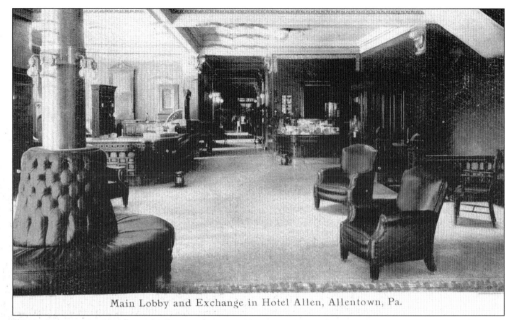

Main Lobby and Exchange in Hotel Allen, Allentown, Pa.

This 1912 postcard shows the luxurious and elegant lobby of the Hotel Allen. It was about this time that Teddy Roosevelt was a guest of Hotel Allen. From a balcony of the hotel, he addressed a large crowd gathered in Center Square.

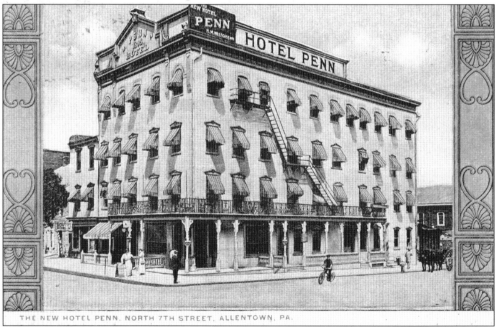

THE NEW HOTEL PENN, NORTH 7TH STREET, ALLENTOWN, PA.

Located at 101 North Seventh Street, the Hotel Penn traces its heritage back to the early days of Allentown. The first hotel at this location opened around 1810 in a house originally owned by the daughter-in-law of William Allen, the city's founder. Over the years, the hotel was upgraded and changed ownership. In the late 1800s, Hotel Penn was popular with farmers, and during World War I, it was popular with industrial workers. In the 1980s, the City of Allentown renovated the building. Today, senior citizens occupy what remains of the Penn Hotel.

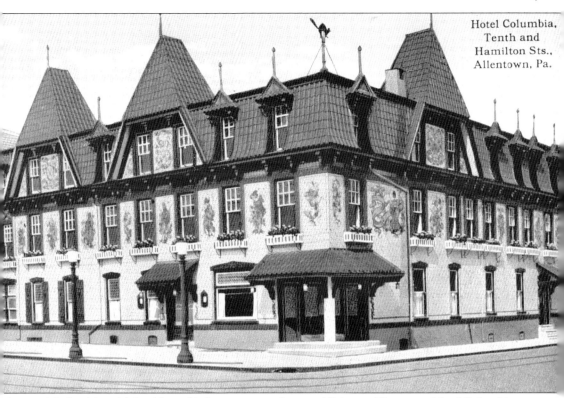

Hotel Columbia, with its old-world charm, was a welcome addition to Allentown. Hotel Columbia fell victim to increased competition from newer hotels and was demolished in 1929. A vacant lot remained at its prime Tenth and Hamilton Streets location throughout the Great Depression.

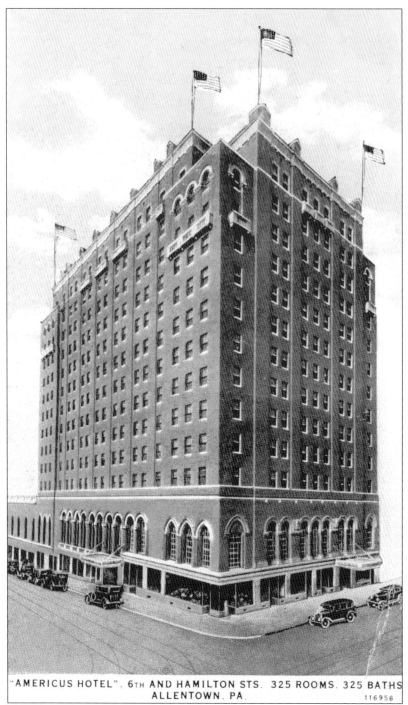

"AMERICUS HOTEL", 6TH AND HAMILTON STS. 325 ROOMS. 325 BATHS
ALLENTOWN, PA. 116956

Named for Spanish explorer Amerigo Vespucci, the Americus Hotel opened on September 13, 1928. The opening of a new hotel on Hamilton Street was a big event for the city. Mayor Malcolm Gross and Harry Trexler presided over the ground-breaking ceremonies, and 700 guests attended a party on opening night. In honor of its namesake, the interior walls of the hotel had elaborate murals depicting the Spanish Empire.

18

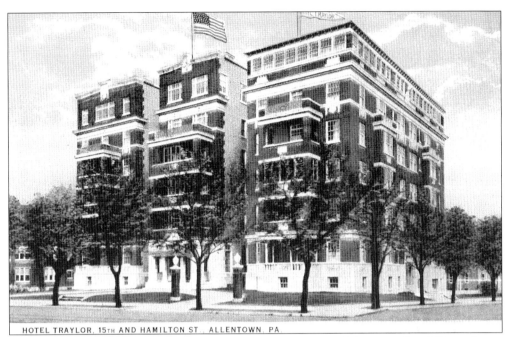

HOTEL TRAYLOR, 15TH AND HAMILTON ST., ALLENTOWN, PA.

Located at Fifteenth and Hamilton Streets, Hotel Traylor was built in 1917. The addition, shown in the bottom postcard, was built in 1929. Hotel Traylor advertised itself as "An Ideal Home for Traveling Men." Babe Ruth was among one of the notable guests who stayed at the Traylor.

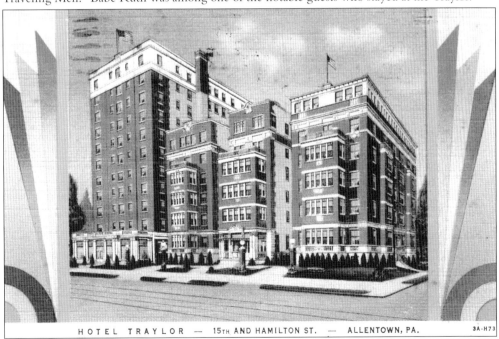

HOTEL TRAYLOR — 15TH AND HAMILTON ST. — ALLENTOWN, PA. 3A-H73

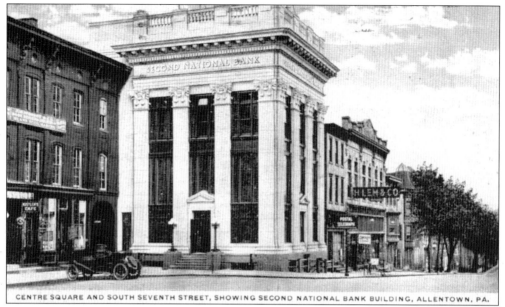

Founded by William H. Ainey, Allentown's Second National Bank began operations in 1864. Located at the southeast corner of Center Square, the building, as shown in this postcard, was actually the bank's third at the same location. Second National Bank would continue business until 1954, when it merged with Allentown National to become the First National Bank of Allentown. This postcard also shows the storefront of H. Leh and Company, one of Allentown's leading department stores.

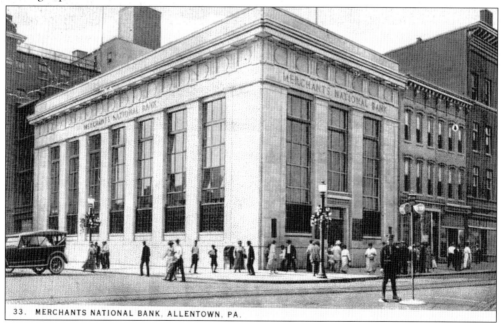

33. MERCHANTS NATIONAL BANK, ALLENTOWN, PA.

Merchants National Bank opened its doors for business in 1903. Its building was located across the street from the Second National Bank on the southwest corner of Center Square. The building, as shown here, was completed in the late 1920s. Prior to this time, the bank conducted business in the lower level of the YMCA building.

20

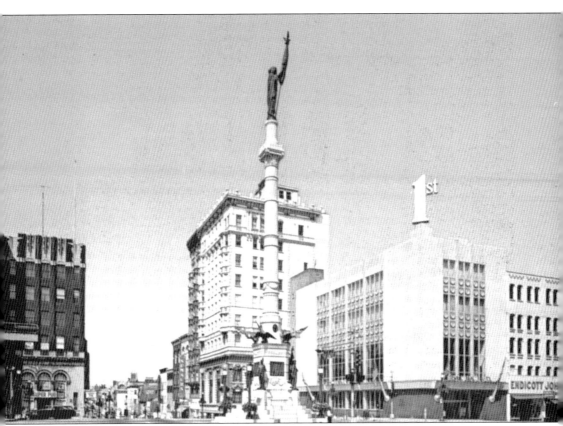

The First National Bank of Allentown was formed in 1954 by the merger of Allentown National Bank and Second National Bank. The bank's headquarters building was built on the site of the Hotel Allen in 1958. In 1987, the First National Bank of Allentown merged into a regional banking group known as Meridian.

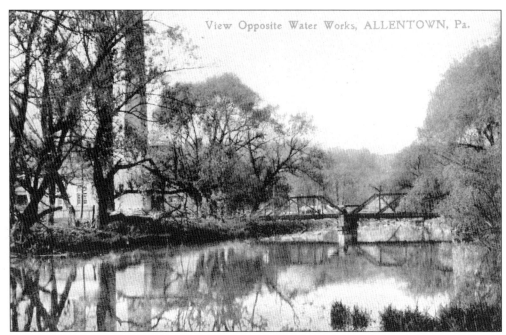

The City of Allentown purchased the assets of the Allentown Water Company in 1868. Also located at the water works was an 80-room resort known as the Fountain House at Crystal Springs. The facility, shown in these two postcards, was replaced in 1929.

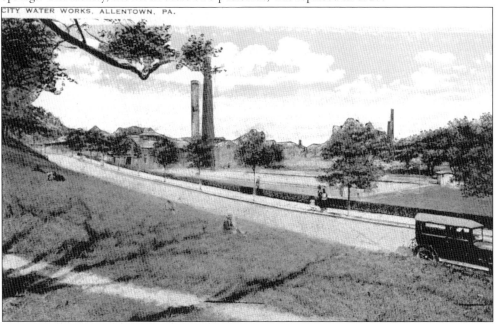

CITY WATER WORKS, ALLENTOWN, PA.

Two

SCHOOL DAYS

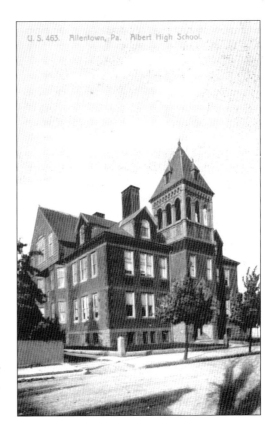

Pictured in this 1906 postcard is Allentown's first structure built for use exclusively as a high school. The building opened its doors for students in 1893. Its use as a high school lasted only 23 years. In 1916, the new, much bigger high school opened on Seventeenth Street.

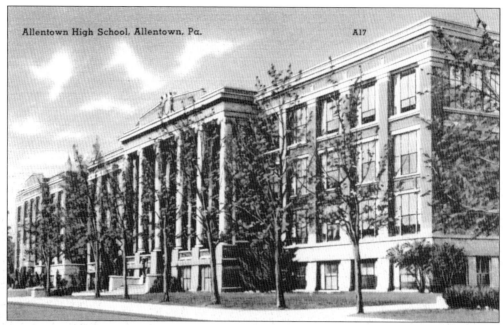

Allentown High School, Allentown, Pa. A17

Allentown High School opened in 1916, during a period of rapid growth in the city. For a time, it was one of the biggest high schools in Pennsylvania. The school was renamed Allen High School in 1961 to honor the city's founder, William Allen. The school produced many notable graduates, including CEOs and state championship sports teams.

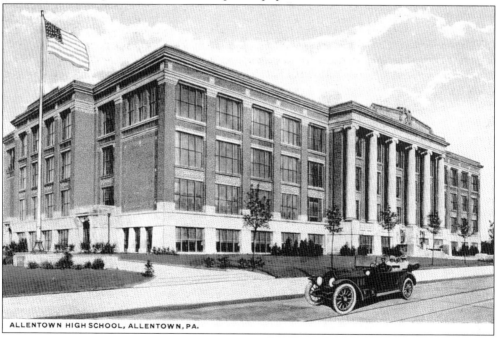

ALLENTOWN HIGH SCHOOL, ALLENTOWN, PA.

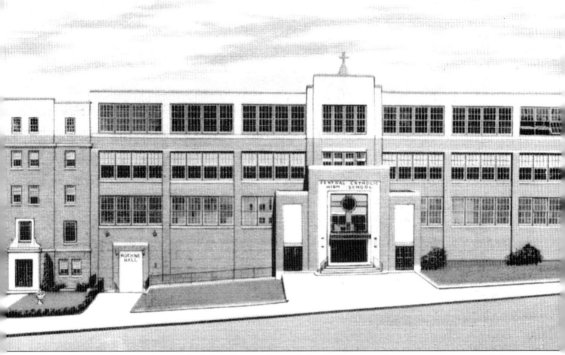

Allentown Central Catholic High School was formed in 1943 from the merger of two high schools. Before this time, students had the choice to attend Allentown Catholic High School, founded by the Immaculate Conception Parish, or the Central Catholic High School, founded by the Sacred Heart Parish.

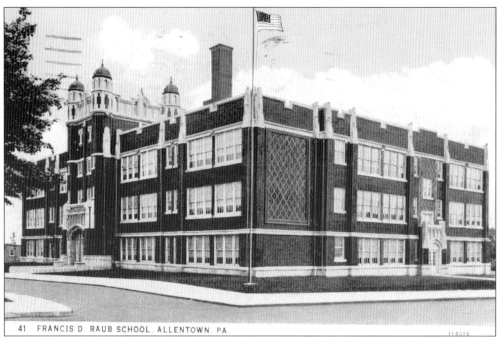

41 FRANCIS D. RAUB SCHOOL, ALLENTOWN, PA

Raub Junior High School was built in 1923 as an elementary school. Its Tudor-like walls housed the latest in academic facilities. To reflect the thinking of the day, it was also equipped with the latest in vocational equipment. Today, Raub is one of four middle schools in Allentown.

Pictured here is the Herbst Elementary School at Fifth and Chew Streets. The school was named for Dr. Henry Herbst, a school board member and former mayor of Allentown. After educating an estimated 30,000 students, Herbst Elementary School was shut down in 1977 due to declining enrollment. Sacred Heart Hospital bought the building, demolished it in 1979, and replaced it with medical offices.

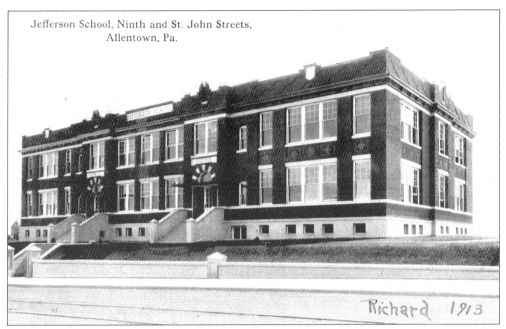

Jefferson School, Ninth and St. John Streets,
Allentown, Pa.

Richard 1913

Opened in 1910, Jefferson Elementary School was the first to be built on the city's south side.
The signs over the doors indicate separate entrances for boys and girls.

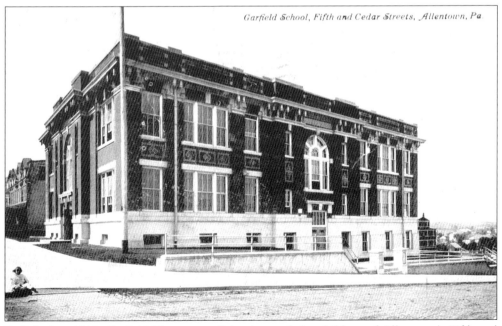

Garfield School, Fifth and Cedar Streets, Allentown, Pa.

Built before 1910, Garfield Elementary School served the children of Allentown's Fifth and
Chew Streets neighborhood until 1979.

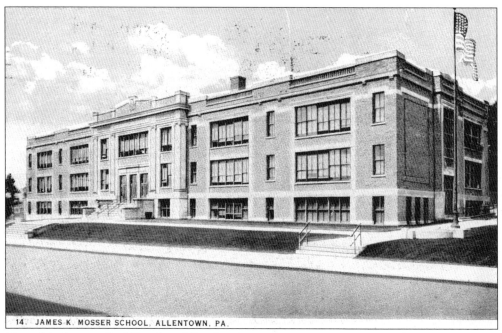

14. JAMES K. MOSSER SCHOOL, ALLENTOWN, PA.

Named in honor of millionaire philanthropist James K. Mosser, Mosser Elementary opened in 1917. James Mosser was an industrialist who co-owned the Lehigh Bricks Works and the Mosser and Keck tannery. Mosser was a major donor in the construction of the original Allentown Hospital.

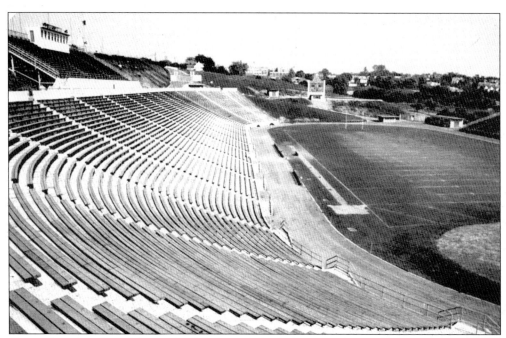

Shown above is a view of the massive Allentown School District Stadium. The stadium had a seating capacity of 25,000 people, making it one of the biggest high school stadiums in the country. It was renamed J. Birney Crum Stadium in 1982, in honor of a longtime Allentown coach.

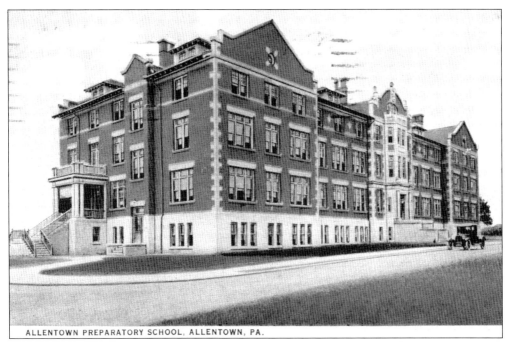

ALLENTOWN PREPARATORY SCHOOL, ALLENTOWN, PA.

Allentown Preparatory School's original location was in downtown Allentown at Fourth and Walnut Streets. The school moved to this spacious building just west of the Muhlenberg College campus in 1916. Today, this building is known as Brown Hall and is used as a dormitory by Muhlenberg College.

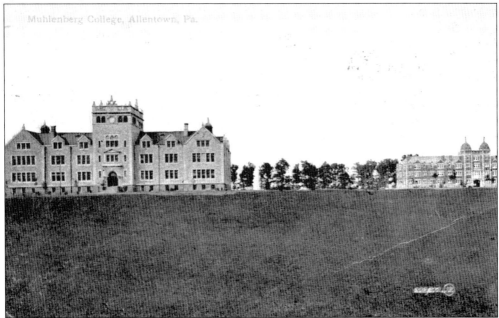

Muhlenberg College held classes for the first time on September 2, 1867. Muhlenberg's first campus was at Fourth and Walnut Streets in downtown Allentown. In need of more room, the college moved in 1904 to its present location at Twenty-third and Chew Streets. Shown above is a 1910 view of the new campus.

29

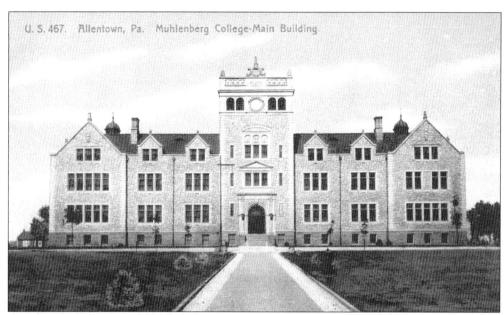

Muhlenberg built two buildings when it first moved to its present location. The beautiful, ornate structure on the top postcard is now known as Ettinger Hall and houses many of Muhlenberg's liberal arts and business departments. Muhlenberg's first dormitory, shown on the bottom postcard, was named Berks Hall. Today, Berks Hall is part of the East Hall dormitory complex.

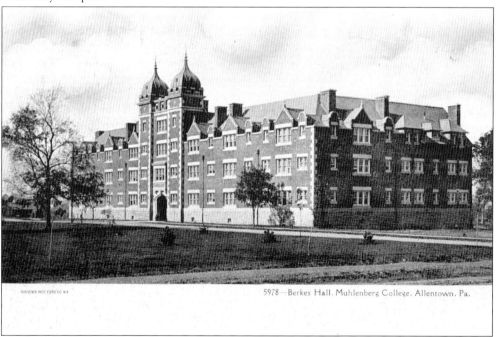

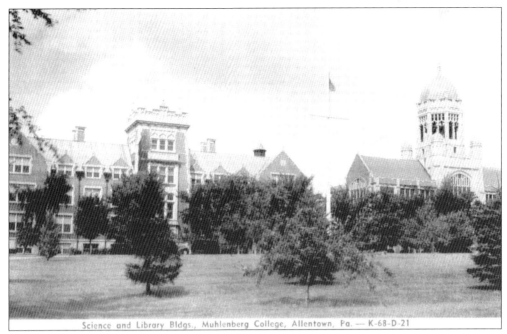

Science and Library Bldgs., Muhlenberg College, Allentown, Pa. — K-68-D-21

This postcard shows Muhlenberg's Trumblower Science Center on the left and the Hass Building on the right. The Hass Building houses the college's administrative rooms, including the president's office.

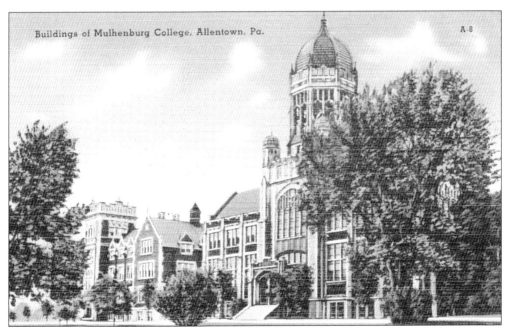

Buildings of Mulhenburg College, Allentown, Pa. A-8

The Haas and Trumblower Buildings are shown in a different view in this postcard. Muhlenberg was named for Henry Melchior Muhlenberg, patriarch of the Lutheran Church in America. The Haas Building honors the Reverend Dr. John A. W. Hass, a popular president of Muhlenberg College.

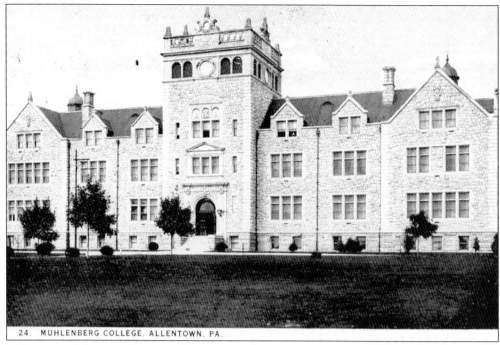

24. MUHLENBERG COLLEGE, ALLENTOWN, PA.

This postcard shows a close-up of Ettinger Hall shortly after its completion in 1904. Ettinger Hall was named in honor of Dr. George T. Ettinger, who was, along with other responsibilities, president of the Allentown Library Board during the 1940s.

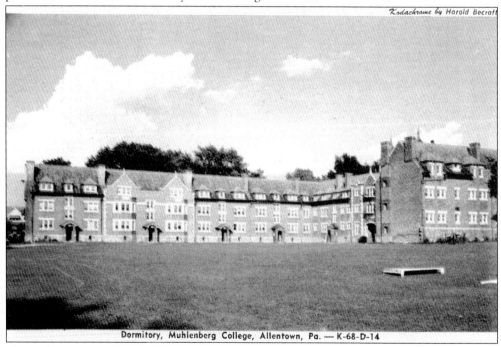

Kodachrome by Harold Becraft

Dormitory, Muhlenberg College, Allentown, Pa. — K-68-D-14

Shown here is a 1950 view of one of Muhlenberg's dormitories known as East Hall. Another dormitory, named in honor of Martin Luther, was built along the left-hand side of this picture in 1957.

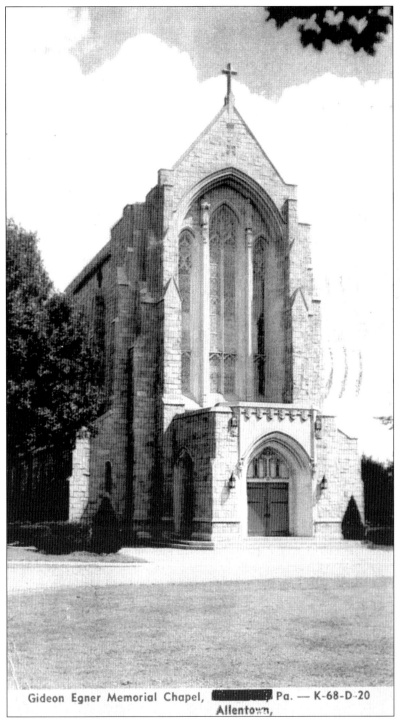

Gideon Egner Memorial Chapel, ▓▓▓▓▓▓ Pa. — K-68-D-20
Allentown,

The beautiful Egner Memorial Chapel is a befitting addition to a college with strong ties to the Lutheran Church. Large and intricate stained glass windows provide ample light to the vaulted interior. Music for services is provided by a 2,600-pipe organ. Besides worship, Egner Chapel is used for teaching, concerts, and academic functions.

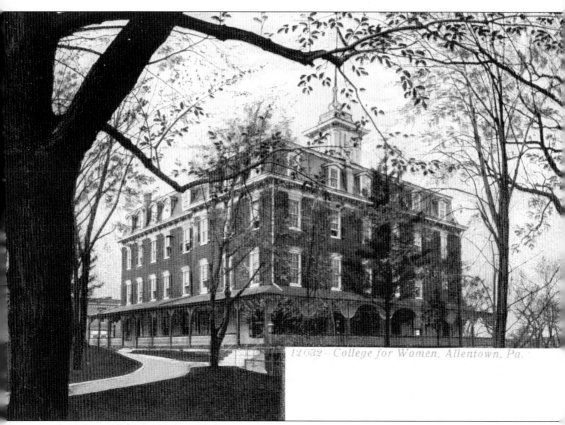

12032 – College for Women, Allentown, Pa.

Like Muhlenberg, Cedar Crest College started in downtown Allentown. Shown above is a 1907 view of Cedar Crest's first building, located at Fourth and Turner Streets. At this time, the college was known as Allentown College for Women. The college changed its name in 1915, when it moved to its present location overlooking Cedar Creek. The building, shown here, became a hotel appropriately named the College Hotel. In 1964, the hotel was demolished to make way for a parking lot.

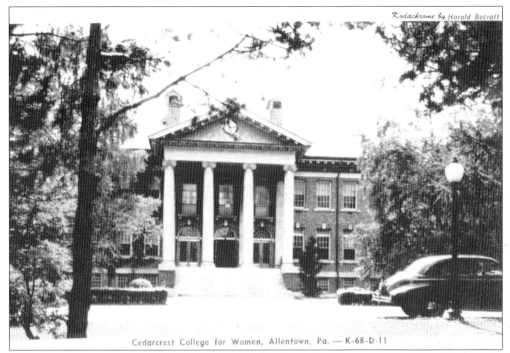

Cedarcrest College for Women, Allentown, Pa. — K-68-D-11

The Administration Building was Cedar Crest College's first new building at its present location. This postcard shows some of the many trees that dot the Cedar Crest campus. The campus includes a nationally registered arboretum, with more than 130 species of trees.

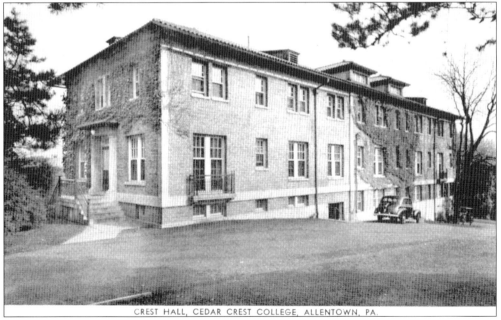

CREST HALL, CEDAR CREST COLLEGE, ALLENTOWN, PA.

Shown above is Crest Hall, another early Cedar Crest College building. The college has grown to serve 1,400 students, who study, live, and play in 16 buildings on 85 beautiful acres in suburban Allentown.

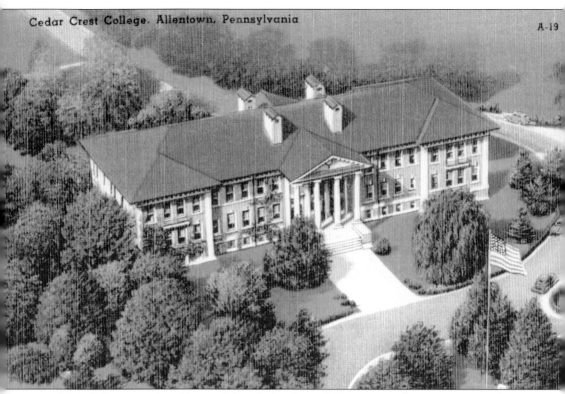

This 1940s-era postcard is proof that Cedar Crest College came a long way since it first met in the basement of Zion Reformed Church.

Three

CITY PARKS

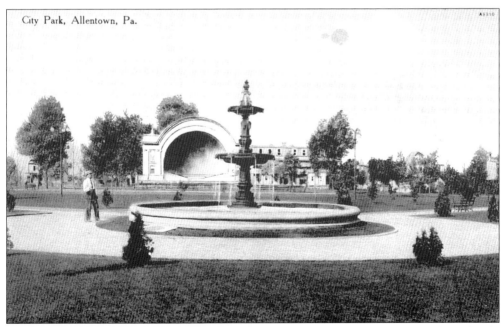

City Park, Allentown, Pa.

Shown above is a view of West Park, Allentown's oldest park. West Park is seen here shortly after it opened in 1908. The bandstand shown on this card is still in use today.

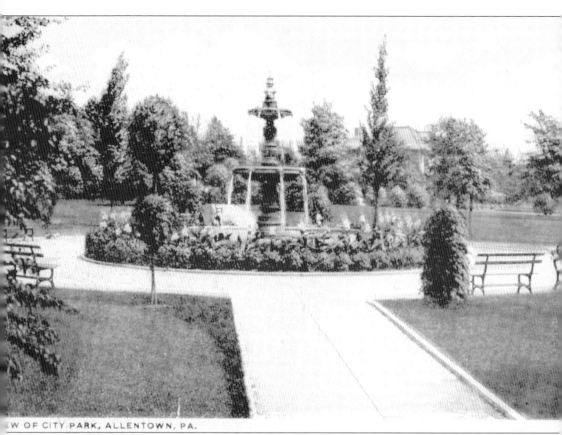

W OF CITY PARK, ALLENTOWN, PA.

Shown here is another view of West Park. This postcard, which was mailed in 1922, shows the Victoria cast-iron fountain. West Park was made possible through generous contributions from Gen. Harry Trexler. General Trexler took an active role in the early development of Allentown's park system. Until his death in 1934, he donated either money or land to build Trexler Park, Cedar parkway, the Allentown Municipal Golf Course, and the Trout Nursery in the Little Lehigh Parkway. His will established a foundation that continues to provide funds for the betterment of Allentown's parks to this day.

The Little Lehigh Parkway is Allentown's flagship park and is the envy of much larger cities. Stretching for three miles along the Little Lehigh Creek, the park offers a wide range of activities on its 1,000 acres.

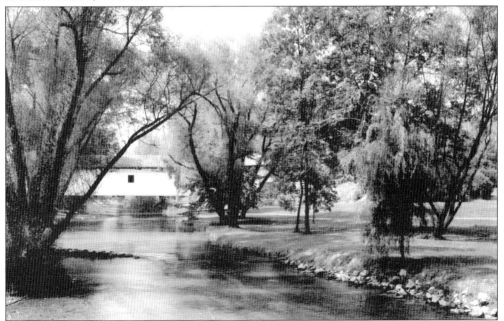

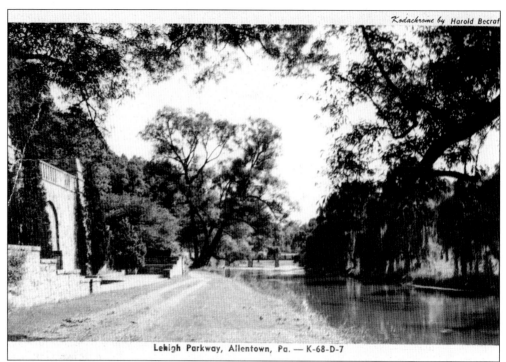

Lehigh Parkway, Allentown, Pa. — K-68-D-7

The scenic Little Lehigh Creek meanders its way through the Lehigh Parkway. The Little Lehigh is well stocked with trout from the Lil-Le-Hi nursery, making it a popular destination for fisherman. The wall, shown on the left of this postcard, was a Works Projects Administration (WPA) project.

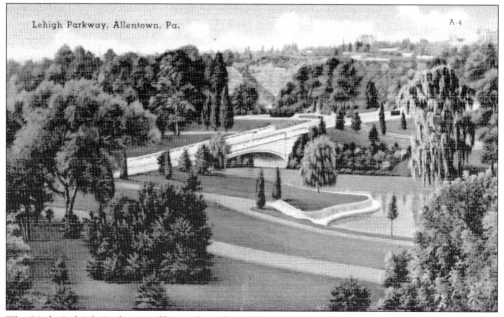

Lehigh Parkway, Allentown, Pa. A-4

The Little Lehigh Parkway offers miles of trails for motorists, bicyclists, horseback riders, and strollers. The bridge shown in this postcard was built by the city in 1933; the construction of streamside retaining walls was another New Deal project.

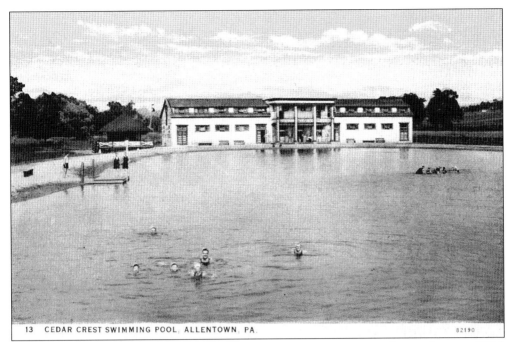

13 CEDAR CREST SWIMMING POOL, ALLENTOWN, PA. 82190

Built in the late 1930s, the Cedar Crest swimming pool and surrounding park was a WPA project. Other Allentown parks that the WPA built are Irving, Jordan, Allen, Riverfront, and Fountain Parks.

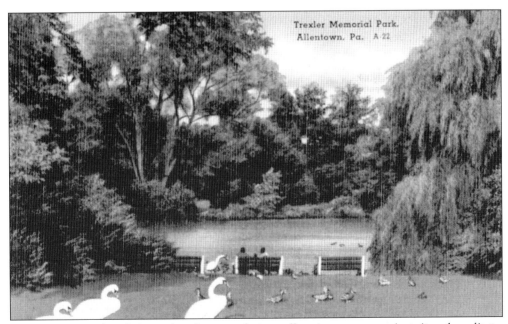

Trexler Memorial Park.
Allentown, Pa. A-22

Trexler Memorial Park is a quiet place to take a stroll, enjoy nature, or just sit and meditate. The park, named in honor of General Trexler, was built on the site of his estate. The City of Allentown took ownership of this parcel as a condition of his will.

41

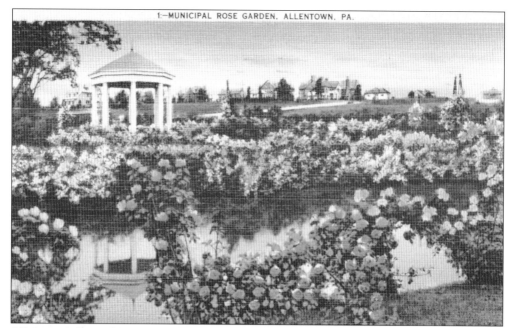

Allentown's beautiful and famous rose garden was the brainchild of Mayor Malcolm Gross. Mayor Gross convinced the city and his friend General Trexler to put up the money for the construction of the garden in 1929. Unfortunately, at about the same time the Great Depression hit Allentown and the rest of the country. Mayor Gross took a lot of criticism for going forward with a frivolous expense such as a garden when teachers where being let go and people where hungry. Fortunately, enough money was found, and the rose garden was completed in 1931.

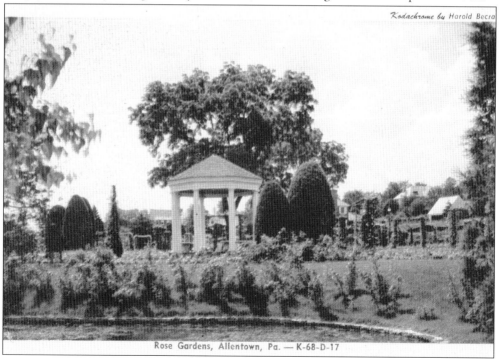

Kodachrome by Harold Becra

Rose Gardens, Allentown, Pa. — K-68-D-17

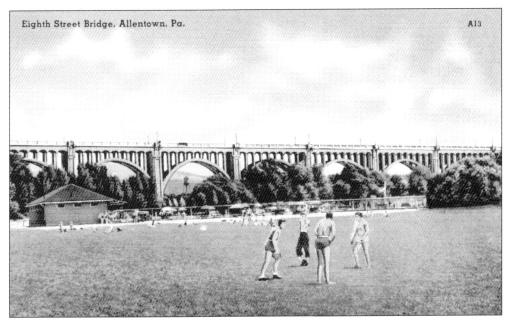

Fountain Park is another of Allentown's parks that owes its existence to the Works Projects Administration. The building of Fountain Park in 1935 provided useful work at the height of the Great Depression. The workers were responsible for the flood wall that protected the park from the Little Lehigh Creek. As seen in this postcard, the graceful arches of the Eight Street Bridge provide a picturesque backdrop for the park.

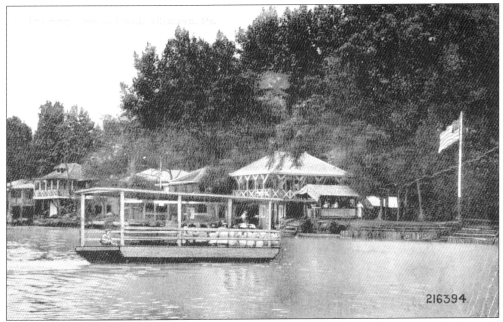

216394

Adams Island, an island in the Lehigh River, was first inhabited by employees of the Lehigh Canal. The Lehigh Coal and Navigation Company used Adams Island to load and unload canal boats.

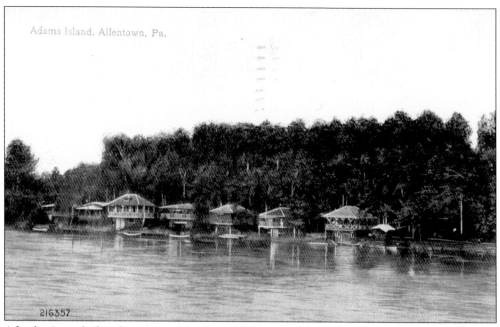

After business declined on the canal, Adams Island was sold. To this day, people continue to live on the island, enjoying a vacation-type atmosphere in the heart of Allentown.

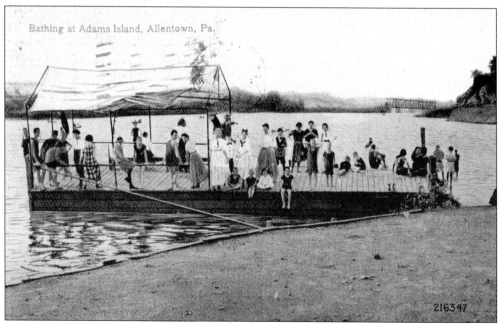

This 1917 postcard shows people of all ages enjoying the tranquil views of the Lehigh River. This scene is from the northern edge of Adams Island. The Lehigh Valley Railroad Bridge can be seen in the distance.

Four

HAVING FUN

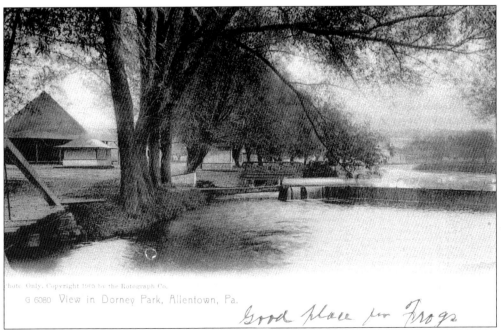

In the 1860s, an enterprising man named Solomon Dorney opened a summer resort west of Allentown along the banks of Cedar Creek. At first, as shown in this 1907 card, the resort consisted of picnic groves and ponds stocked with trout.

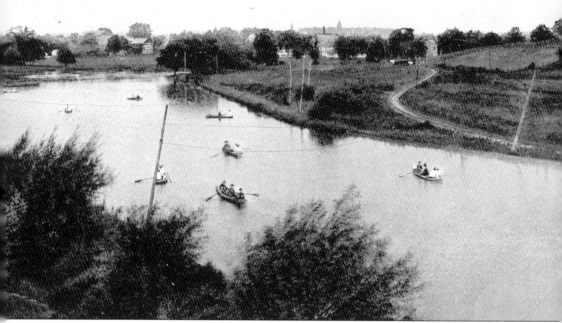

Dorney Park, Boating Pond, Allentown, Pa.

In the early 1890s, the Allentown-Kutztown Trolley Company acquired Dorney Park and added a spur line, shown on the right hand side of this 1909 postcard. For only a nickel, people could travel between Allentown and the park. This increased business for both the trolley company and Dorney Park.

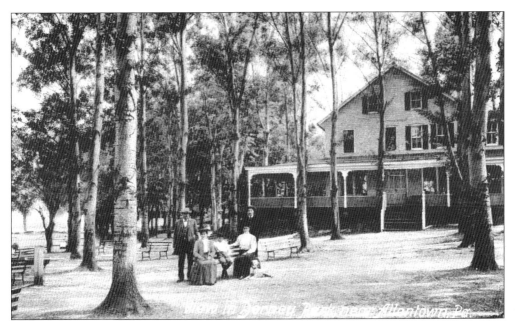

Along with picnic groves, this postcard shows the hotel and restaurant that was added in the 1870s. Also added during this time were Dorney Park's first mechanical rides and even a small zoo.

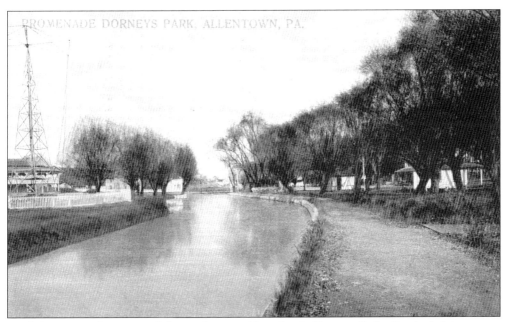

Mailed in 1909, this postcard shows the two sides of early Dorney Park. On the left is a tower supporting a thrill ride, while on the right are picnic spots and a promenade for a worry-free stroll along Cedar Creek.

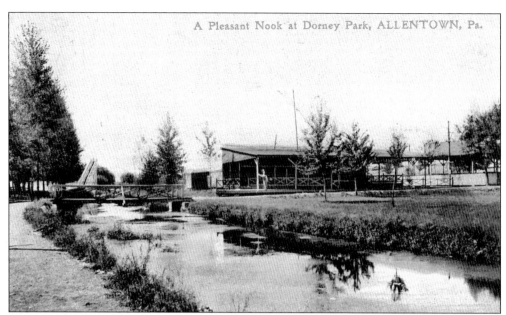

Titled "A Pleasant Nook at Dorney Park," this postcard proves that some people went to Dorney Park for a nice, quiet getaway.

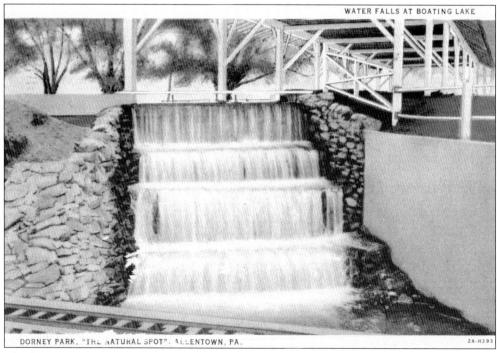

The dam and waterfalls shown here created the Dorney Park boating lake. During the 1930s, the falls were illuminated with multi-colored lights. In the foreground, the tracks of the miniature railroad can be seen.

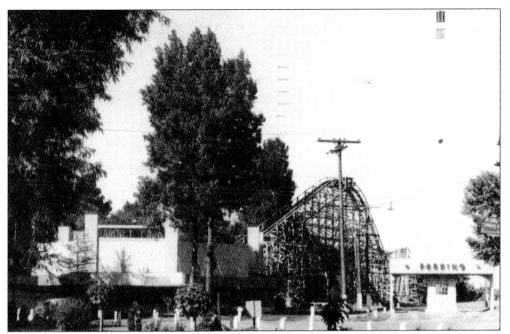

Built in 1923, the roller coaster shown in this 1949 postcard is still in use today. When it was built, the Dorney Park roller coaster was one of the biggest in the country. Today, it is dwarfed by other Dorney Park attractions.

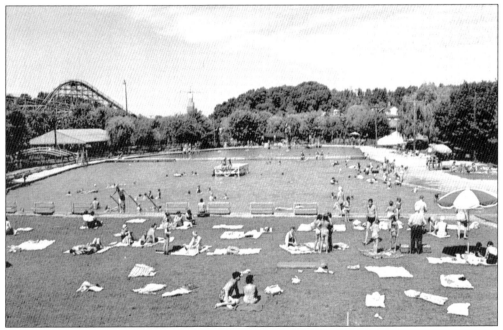

One of the many attractions at Dorney Park was this gigantic pool fed by the cool waters of Cedar Creek. This pool was removed to make way for other rides, but in 1985, Dorney Park opened one of the first water parks in the Northeast.

Shown above is a 1960s-era Dorney Park attraction. What Solomon Dorney started over 130 years ago grew to over 100 rides situated on 200 acres. Today, Dorney Park is one of the oldest amusement parks in the country and is visited annually by tens of thousands of people.

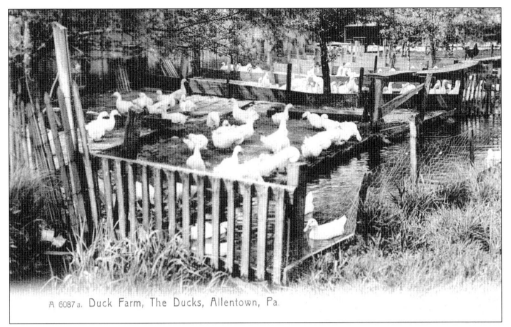

R 6087 a. Duck Farm, The Ducks, Allentown, Pa.

The Duck Farm was located along the trolley tracks that serviced Dorney Park. The farm raised thousands of ducks behind long, white board fences. Seeing the ducks was a much-anticipated part of the open-air trolley ride. Besides being a thrill for the children, seeing the ducks meant that Dorney Park was nearby.

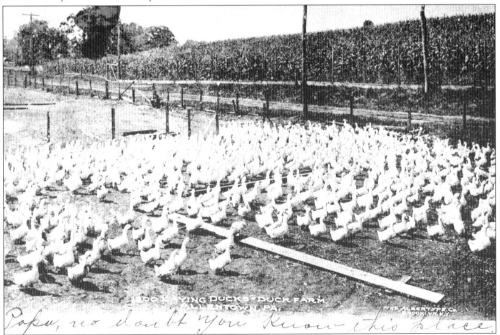

1200 LAYING DUCKS, DUCK FARM, ALLENTOWN, PA.

THE ALBERTYPE CO. BROOKLYN N.Y.

Papa, no doubt you know this place.

51

For a period of time, Allentown had two exceptional amusement parks. Central Park, on the city's east side, was every bit the rival of Dorney Park. Central Park closed around 1950. Today, what once was an amusement park is occupied by a car dealership and a senior citizens housing complex.

In addition to thrill rides, Central Park offered shady spots for picnics. Central Park also had a theater that was very popular with the people of Allentown.

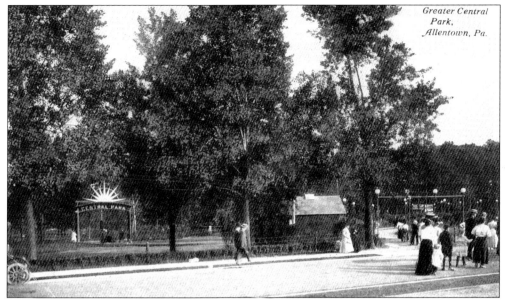

Most people traveled to Central Park via the trolley cars of the Lehigh Valley Transit Company. The trolley company also owned Central Park.

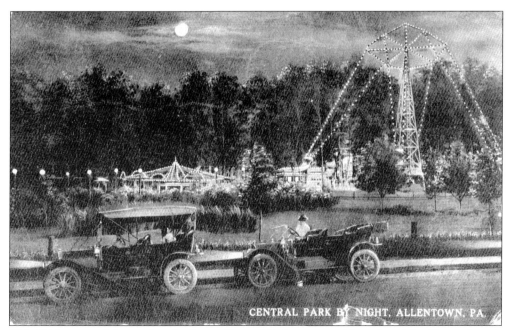

This 1913 postcard shows that the fun at Central Park continued into the night. Shown here is Circle Swing. During the 1920s and 1930s, Central Park was a popular destination for a night of dancing.

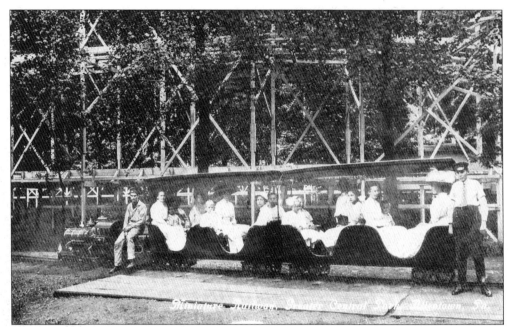

Shown in this postcard that was mailed in 1913 is Central Park's miniature railroad. Also shown in the background is the superstructure of the park's roller coaster.

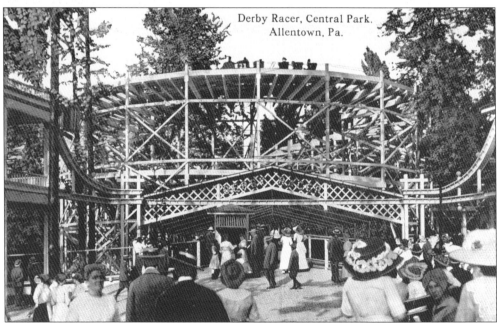

Derby Racer, Central Park.
Allentown, Pa.

Shown in this 1916 postcard is the Central Park roller coaster, the Derby Racer. The Derby Racer opened in 1912 and continued to provide thrills until 1951. Central Park had another roller coaster, named the Cyclone, which was one of the longest roller coasters in the country at the time.

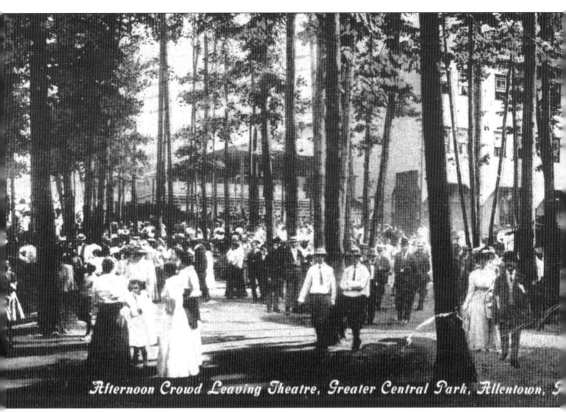

Afternoon Crowd Leaving Theatre, Greater Central Park, Allentown, S

One of the attractions at Central Park was a theater. As shown by the large crowd in this 1917 postcard, the Central Park Theater was popular with the people of Allentown.

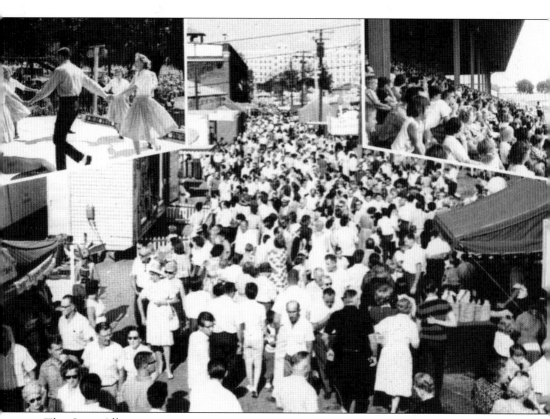

The Great Allentown Fair owes its existence to a group of farmers who first got together in 1852 with the purpose of advancing agriculture in Lehigh County. From this initial meeting, the Agricultural Society of Lehigh County was born. The society decided that an annual fair was an ideal way to promote its goals. The first Allentown Fair was held later that same year on Fourth Street between Walnut and Union Streets. The first fair was a resounding success, grossing over $1,200. Building on this success, the society purchased 14 acres on Liberty Street between Fifth and Sixth Streets. The fair moved again in 1889 to its present address at Seventeen and Chew Streets. Over the years, numerous improvements were added to the fairgrounds, including a grandstand, exhibit halls, and stalls to show off livestock. The fair grew in fame over the years, attracting tens of thousands of people every year. This 1960s-era postcard attests to the fair's popularity.

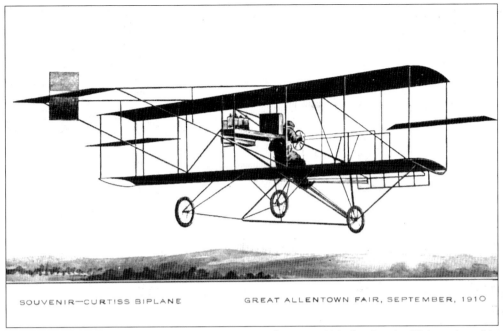

SOUVENIR—CURTISS BIPLANE GREAT ALLENTOWN FAIR, SEPTEMBER, 1910

All things new were popular attractions at county fairs. In 1910, the Curtiss Biplane drew big crowds of people eager to see an airplane, possibly for the first time.

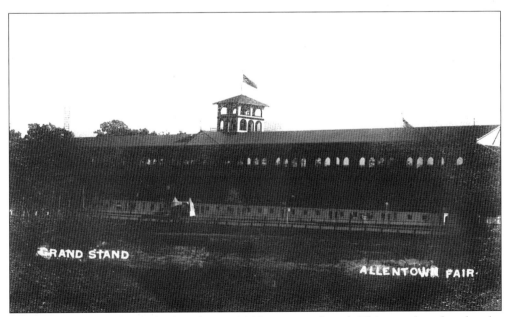

GRAND STAND ALLENTOWN FAIR·

This 1914 postcard shows the brand-new 7,000-seat grandstand. This grandstand replaced a 2,500-seat wooden grandstand built in 1902.

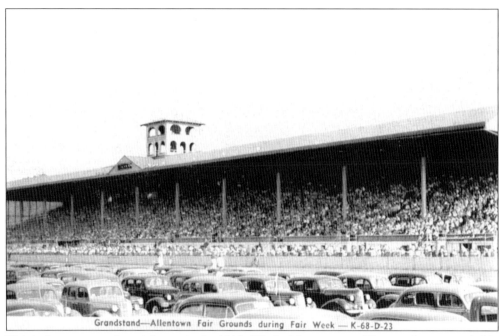

Grandstand—Allentown Fair Grounds during Fair Week — K-68-D-23

This is the same grandstand shown in the 1940s filled with spectators. The people were probably waiting for the start of an automobile race around the half-mile oval. Harness and automobile races were popular with the fairgoers until the 1950s.

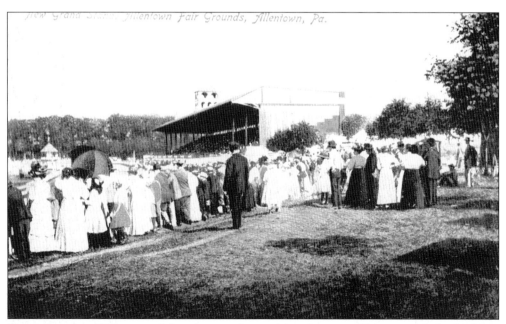

Shown here is a 1912 postcard showing people watching the races. This postcard clearly shows that the fairgrounds were covered in grass. The society paved the fairgrounds in the 1940s to eliminate muddy conditions caused by heavy rains and to better accommodate vehicular traffic.

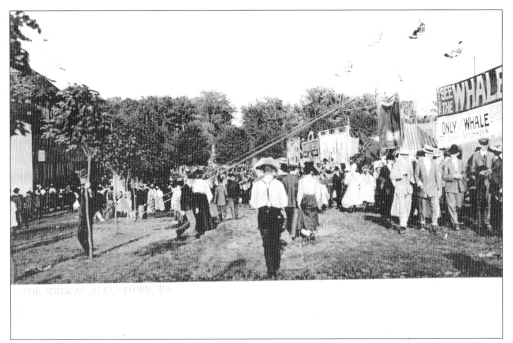

This *c.* 1910 postcard shows a few of the many attractions available on the fair's midway. In the distance is a Ferris wheel, and in the foreground is a sign offering a glimpse of a 75-foot whale. This postcard also offers a look at how people dressed to attend the fair. As compared to today, people wore their best clothing, giving evidence that a trip to the fair was an important annual event.

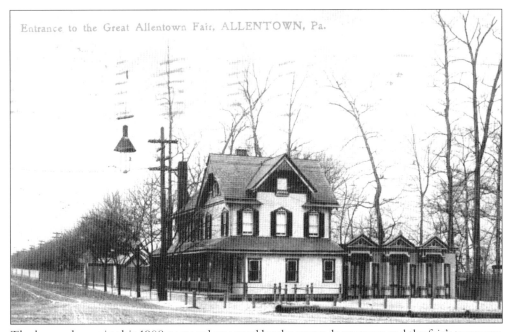

The house shown in this 1908 postcard was used by the grounds overseer and the fair's treasurer. Also shown is the new entranceway added a few years before.

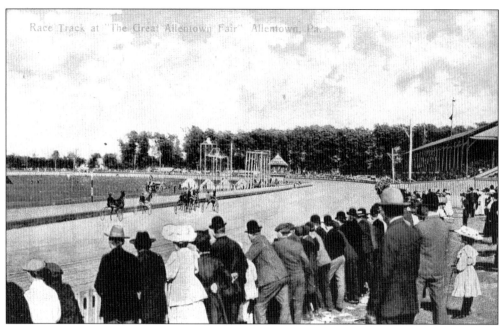

Race Track at "The Great Allentown Fair" Allentown, Pa.

These two 1908 postcards show two different views of fairgoers enjoying harness races. Also shown on the right-hand side of both postcards is the fairgrounds old grandstand.

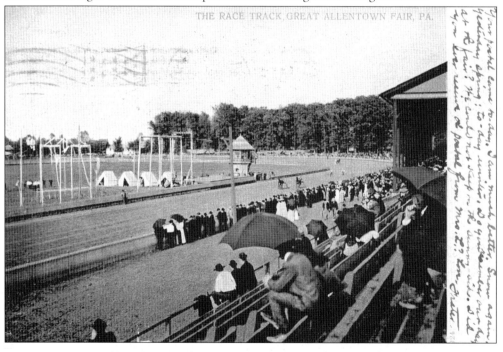

THE RACE TRACK, GREAT ALLENTOWN FAIR, PA.

Five

DOWNTOWN

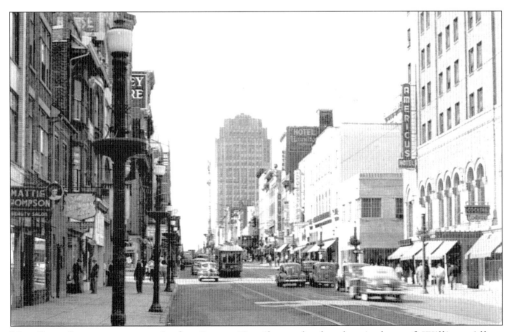

Hamilton Street was named after James Hamilton, the brother-in-law of William Allen, the city's founder. James Hamilton was governor of Pennsylvania in the years immediately preceding the Revolutionary War. Former Governor Hamilton spent part of the Revolutionary War in Allentown under house arrest.

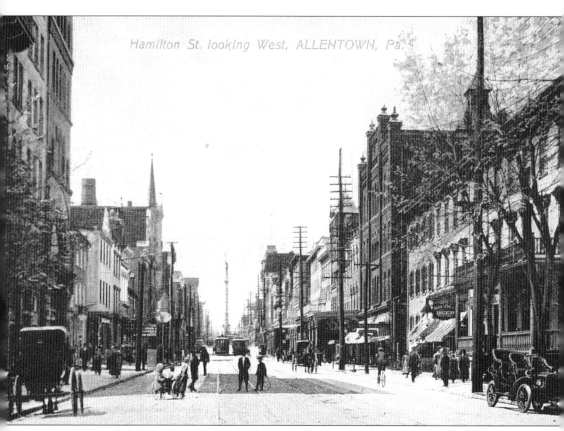

This postcard shows Allentown's Hamilton Street around 1905. Looking closely at this card, one can see the varied modes of transportation used at the time. Parked along Hamilton Street are horse buggies and an automobile. In the distance, one can see two streetcars and even a person on a bicycle.

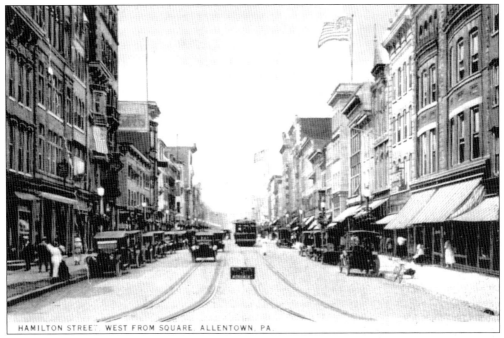

HAMILTON STREET, WEST FROM SQUARE, ALLENTOWN, PA.

The view above shows Hamilton Street about 10 years after the previous postcard. In this scene, there are no horse buggies and a lot more cars.

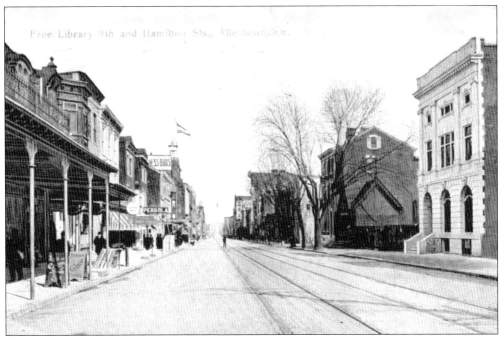

Free Library 9th and Hamilton Sts., Allentown, Pa.

This picture of Allentown was taken at Ninth and Hamilton Streets looking east. Shown on the right side of the street is Allentown's first public library building, constructed in 1910. The buildings on the left side of the street, including the Pergola Theater, were demolished to make way for the PP&L Building in the 1920s.

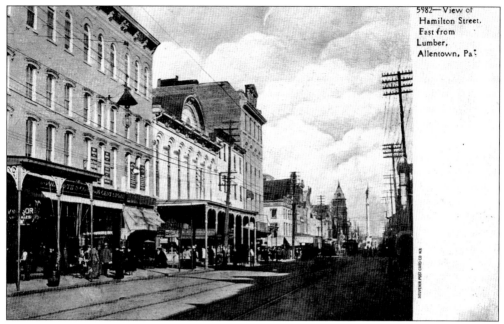

The decorative building with the circular top in the middle of the picture was Allentown's first opera house. The Hagenbuch Opera House opened in 1870 and continued its operations for about 20 years. At the time this picture was taken, the building was occupied by Bowen Grocery Store.

This postcard shows the same section of Hamilton Street as the previous card but from a different direction. The S at the top right of the picture was from the sign for Hess Brothers department store. At the time this scene was captured, Hess Brothers had one of the largest electric signs on the east coast.

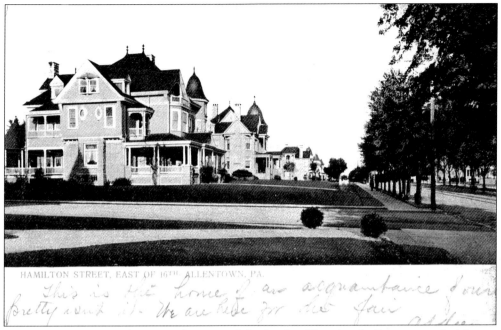

As Allentown grew and prospered, many of the local millionaires built ornate and elaborate mansions along Hamilton Street. Built in the early part of the 20th century, many of these fine homes still survive. Today, the old mansions are occupied by professional offices and businesses.

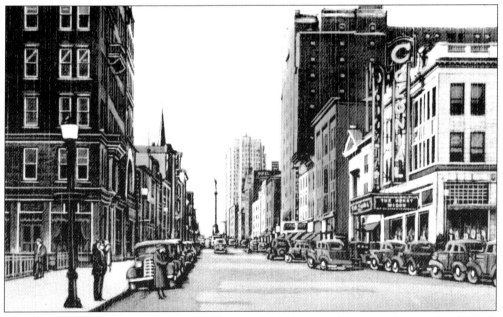

This view shows Hamilton Street at Fifth Street looking west. The recently completed PP&L Building and the new Americus Hotel are shown on the right side of the street. This card is dated by the sign on the Colonial Theater marquee. The film *Merry Widow* was released in 1934.

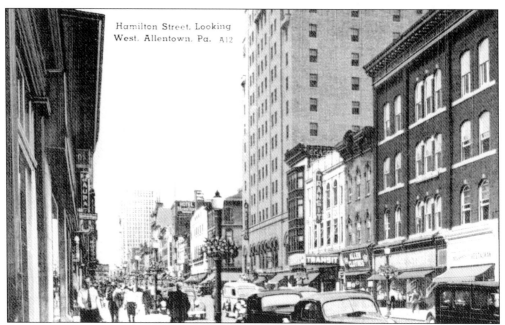

Hamilton Street, Looking
West, Allentown, Pa. A12

Before the advent of suburban malls, Hamilton Street was the shopping mecca for the Lehigh Valley. For many people from miles around, the Christmas season would not be complete without a visit to downtown Allentown. The scene in this *c.* 1935 postcard shows some of the many shops and business located along Hamilton Street.

During the 1970s, Hamilton Street was losing the competition for shoppers to suburban malls. To better compete, the City of Allentown added canopies to protect shoppers from the elements. As seen in this postcard, the canopies obstructed views of architecturally pleasing buildings and monuments.

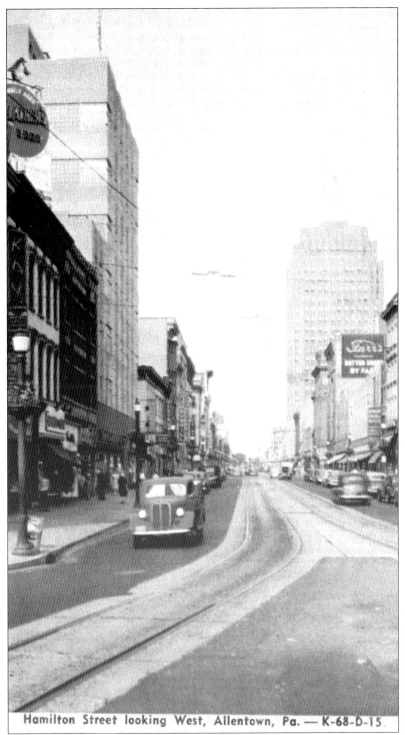

Hamilton Street looking West, Allentown, Pa. — K-68-D-15

This postcard from the late 1930s is notable for signs advertising two of Allentown's favorite businesses of the time. On the right, about midway, is the sign for Farr's Shoe store. Horlachers, one of the local breweries, is advertising its beer at the top left of the card.

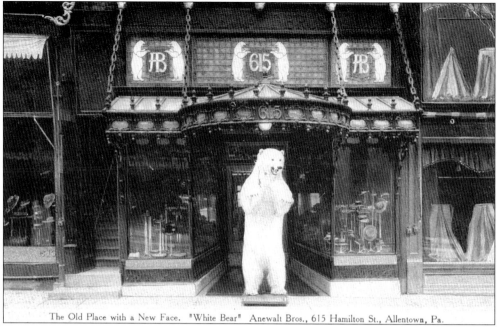

The Old Place with a New Face. "White Bear" Anewalt Bros., 615 Hamilton St., Allentown, Pa.

Shown here are two pictures of a hat and fur store located at 615 Hamilton Street. Officially named the Anewalt Brothers Store, it was known simply as the White Bear Store for obvious reasons. The White Bear Store was the largest and most complete hat and fur store in the Lehigh Valley.

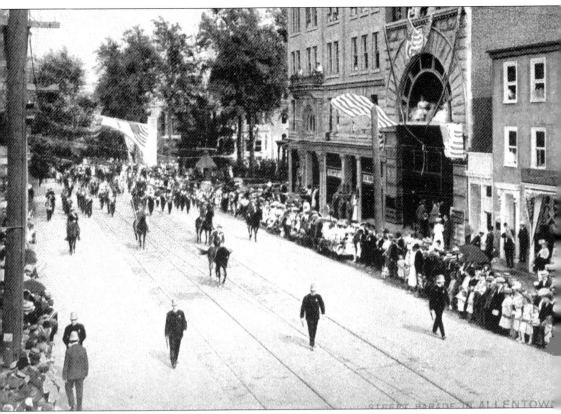

Shown here, in a postcard from 1910, is a parade through Allentown. The reason for the celebration is not clear, but from the many American flags it appears to be either a Fourth of July parade or a parade in honor of Armistice Day.

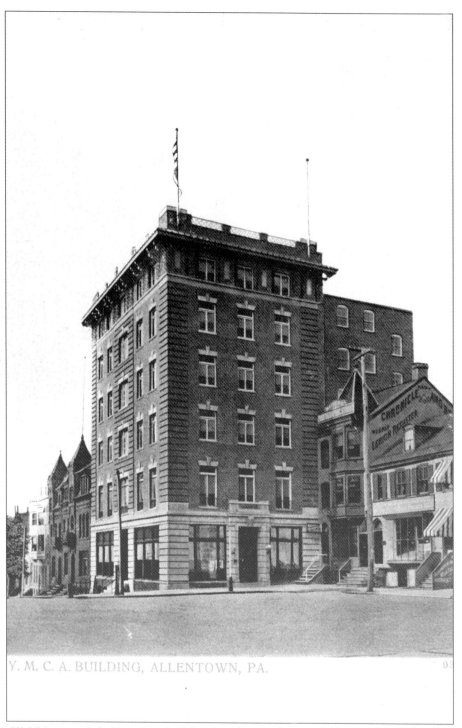

Y. M. C. A. BUILDING, ALLENTOWN, PA.

The YMCA occupied this prime building on the southwest corner of Center Square. The YMCA can trace its first presence in Allentown back to 1858. The Allentown YMCA played host to servicemen from both world wars. Also shown is this postcard are the offices of one of Allentown's newspapers in 1910, the *Lehigh Register*.

70

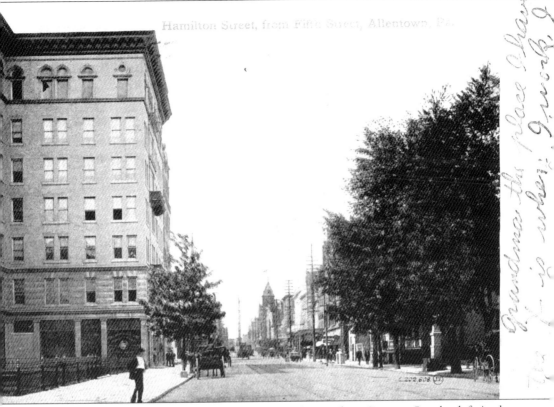

This 1911 postcard captures the scene at Fifth and Hamilton Streets. On the left is the Commonwealth Building, one of Allentown's first true office buildings. Many of Allentown's top professionals and businesses had offices in the Commonwealth to take advantage of the building's prime location across the street from the courthouse.

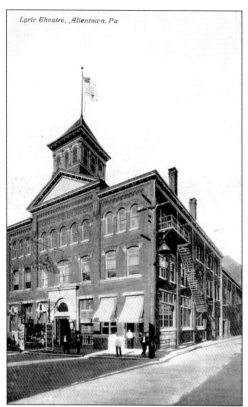

Lyric Theatre, Allentown, Pa.

In the early 1900s, Allentown had more than its share of theaters. In addition to the Lyric and the Orpheum, shown in these two postcards, vaudeville acts could be watched in the Rialto, the Hippodrome, the Pergola, and the Hamilton. The biggest names of vaudeville performed in Allentown, including Jack Benny, W. C. Fields, Fred Astaire, Lila Lee, and Al Jolson. As the golden age of vaudeville came to a close, so did the theaters. Some changed over to motion pictures to survive. The Pergola at Ninth and Hamilton Streets was demolished to make way for the PP&L Building. The *Morning Call* newspaper now occupies the Sixth and Linden Streets location of the old Lyric and Orpheum Theaters.

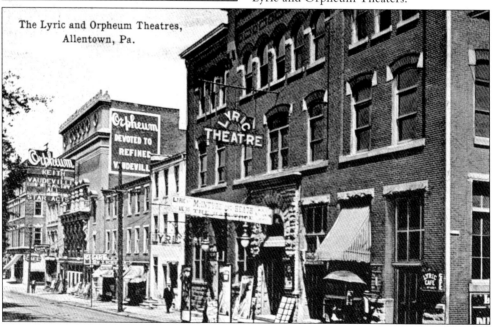

The Lyric and Orpheum Theatres, Allentown, Pa.

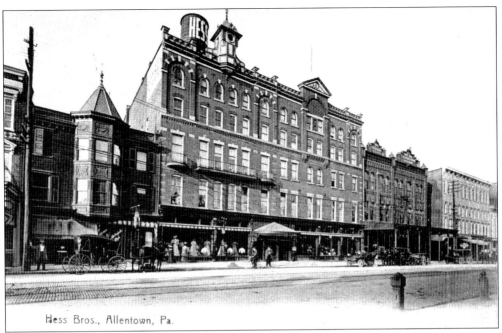

Hess Bros., Allentown, Pa.

In 1897, an annex had just been built on the Grand Hotel located at 831 Hamilton Street, and it needed a tenant. Charles and Max Hess, two brothers from New Jersey, concluded that Allentown was in need of a luxurious store that sold quality goods at fair prices. On February 17, 1897, the Hess Brothers store opened for business for the first time. For the next 99 years, Hess Brothers was a staple of downtown Allentown. Shoppers traveled from miles all over eastern Pennsylvania to shop at Hess Brothers. Eventually, Hess's would succumb to the same pressure felt by many downtown department stores across the country. Hess's closed in January 1996. With its closing, Allentown lost an institution that had come to define the downtown business district.

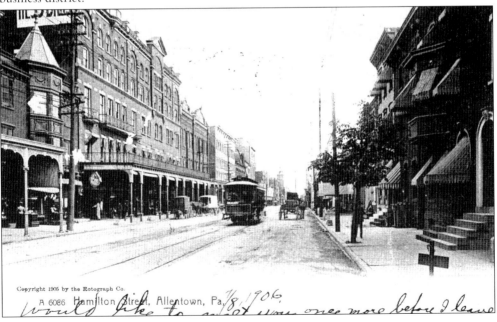

A 6086 Hamilton Street, Allentown, Pa.

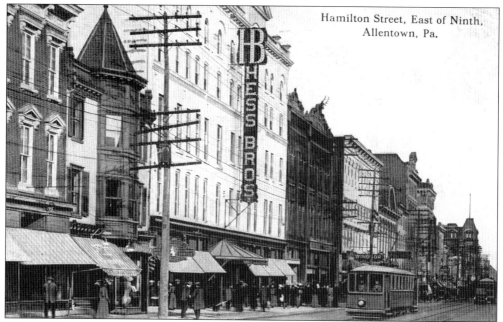

Hamilton Street, East of Ninth,
Allentown, Pa.

This 1915 postcard shows Hess Brothers sporting its new electric sign. This postcard also shows how much the store had grown in less than 20 years. The original store was on one level and measured 50 by 125 feet. By 1915, the store had grown to five levels. Before closing, Hess's would grow to over 250,000 square feet of retail space.

This card from the 1960s shows one of the famous annual Hess Brothers flowers shows. Each year, a different celebrity would visit Allentown and open the flower show. Celebrities such as Gina Lollobrigida, Zsa Zsa Gabor, Barbara Eden, Rock Hudson, and Chuck Connors came to Allentown at the height of their success.

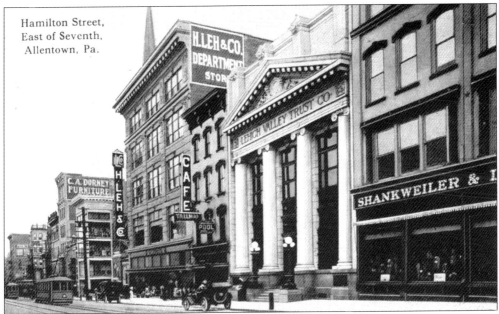

Hamilton Street,
East of Seventh,
Allentown, Pa.

This postcard is notable for showing three venerable Allentown businesses. All three date back to at least the 1880s. H. Leh and Company was a popular department store. Lehigh Valley Trust started business in 1886 and built the bank shown here in 1911. The Lehigh Valley Trust Building remains one of Allentown's prettiest buildings. Marble from Vermont was used to adorn the edifice, and four ionic columns support an impression edifice. A striking stained glass skylight lights the interior of the bank. On the right is the storefront of Shankweiler and Lehr clothing store. This postcard was mailed in 1915.

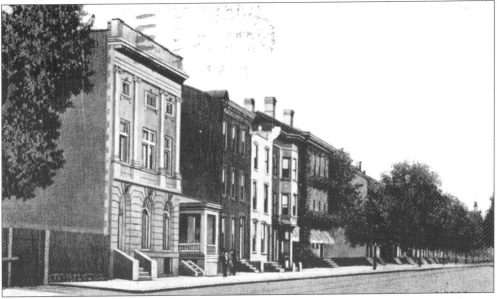

This 1915 postcard shows the recently completed Allentown Public Library, along with some stately town houses. In 1978, thanks to large private donations from Donald Miller, publisher of the *Morning Call*, and others, the Allentown Free Library moved to more spacious quarters at Twelfth and Hamilton Streets.

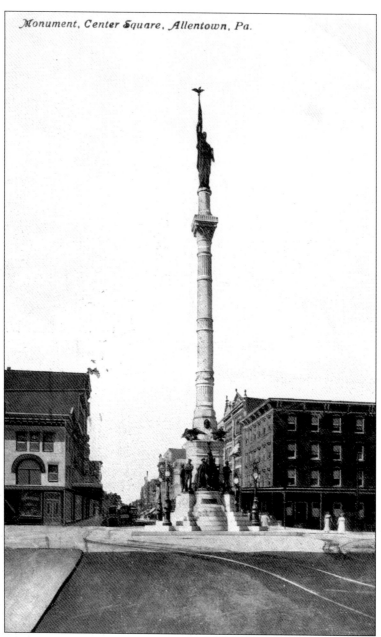

Monument, Center Square, Allentown, Pa.

A memorial to the men of Lehigh County that served in the Civil War, the Soldiers and Sailors Monument was unveiled on October 15, 1889. Costing $43,000 and taking a year to erect, the monument is constructed of Vermont granite with bronze statues. At the base of the 97-foot-tall statue are four reliefs, each telling a different story from a different period of the Civil War. Allentown and Lehigh County sent thousands of volunteers to fight for preservation of the union. In response to President Lincoln's first call for volunteers, men of Allentown eagerly signed up as the Allen Infantry, commanded by Capt. Thomas Yeager, and the Allen Rifles, commanded by Capt. Tilghman Good. Captain Good would reach the rank of colonel and command the 47th Pennsylvania Regiment, made up of men mostly from Lehigh County. Colonel Good would later serve two terms as mayor of Allentown.

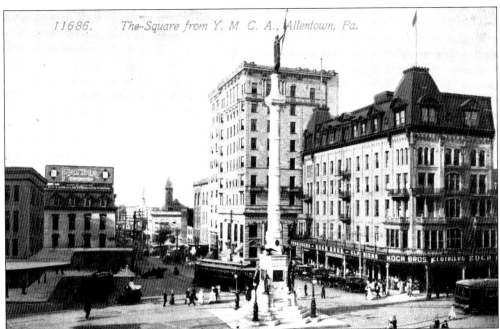

These two postcards show the Soldiers and Sailors Monument as seen from the YMCA building. In the background are the Allentown National Bank Building and the Hotel Allen. Many Civil War regiments would hold reunions and visit the monument to honor their fallen comrades and to have their pictures taken. Besides being a home to the monument, Center Square played host to celebrations to mark the end of both world wars.

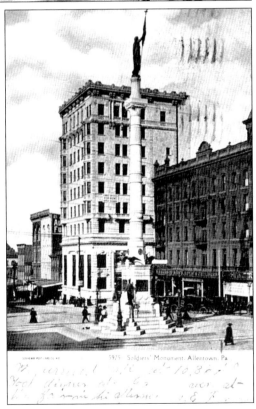

77

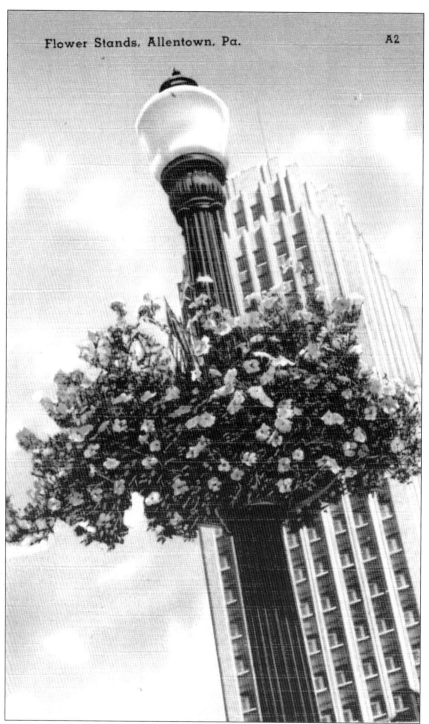

This postcard uses the Pennsylvania Power and Light Building as a backdrop to showcase Allentown's famous flower stand. These flower stands doubled as light posts and were placed all over the downtown district. For years, the image of these flower stands served as a symbol for the city of Allentown.

Six

TRANSPORTATION

During the glory days of rail travel, Allentown had two passenger stations. Both were located on Hamilton Street within eyesight of each other at opposite ends of the bridge over the Jordan Creek. Both were built in 1890 and designed to impress passengers with the affluence and grandeur of the competing railroad companies.

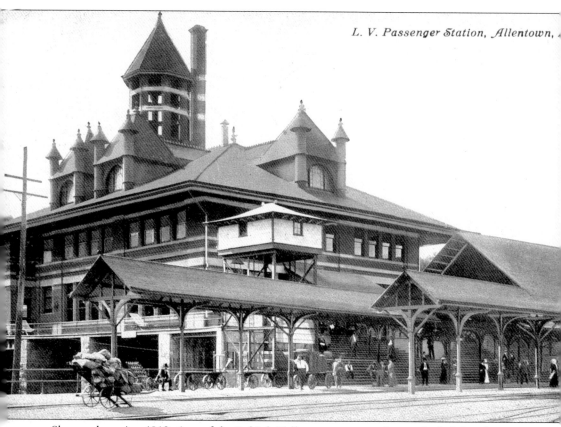

Shown above is a 1912 view of the Lehigh Valley passenger station at the height of its success. Asa Packer founded the Lehigh Valley Railroad to compete with the Lehigh Canal for the business of hauling anthracite coal to market.

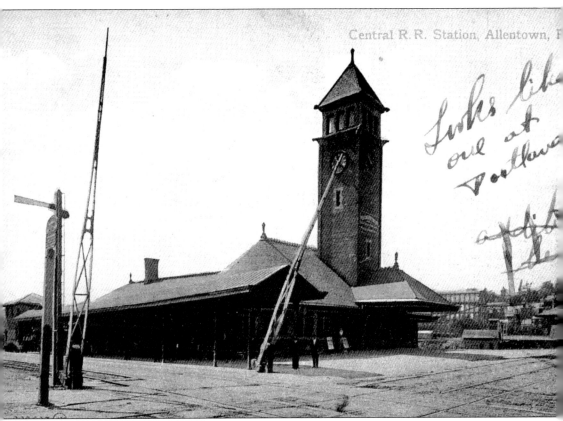

This postcard shows the passenger station of the Central New Jersey Railroad as it appeared in 1907. While both rail companies provided passenger service to Allentown, their main source of income was the hauling of freight to and from the many industrial plants of the Lehigh Valley.

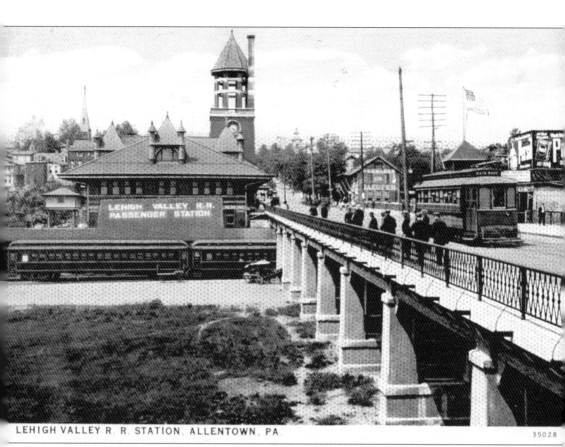

LEHIGH VALLEY R. R. STATION, ALLENTOWN, PA.

35028

This 1928 postcard shows an electric trolley getting ready to pick up passengers at the station. On the opposite side of Hamilton Street from the station are two advertisements. One is for Daeufer, one of the many beers brewed in Allentown in the 1920s. The other billboard is for Persil, a popular laundry detergent of the day.

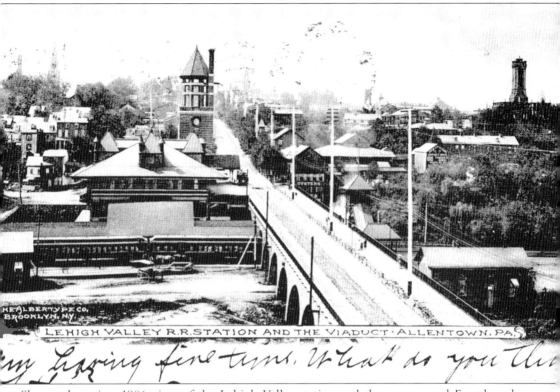

LEHIGH VALLEY R.R. STATION AND THE VIADUCT · ALLENTOWN, PA.

Shown above is a 1906 view of the Lehigh Valley station and the area around Fourth and Hamilton Streets. In the early 1960s, the station fell victim to the urban renewal efforts. At this time, the once grand station that saw thousands of visitors pass through its doors was demolished in the name of progress.

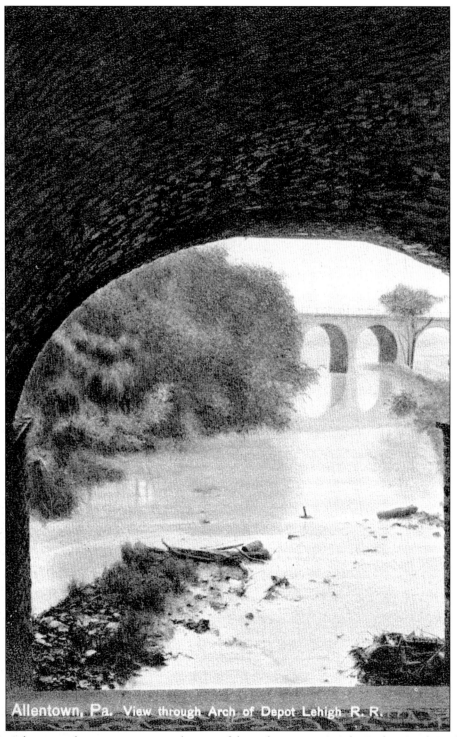

Allentown, Pa. View through Arch of Depot Lehigh R. R.

This early postcard captures a scene under one of the arches supporting the Jordan Creek Bridge. The arched structure in the background is the Linden Street Bridge over the Jordan Creek.

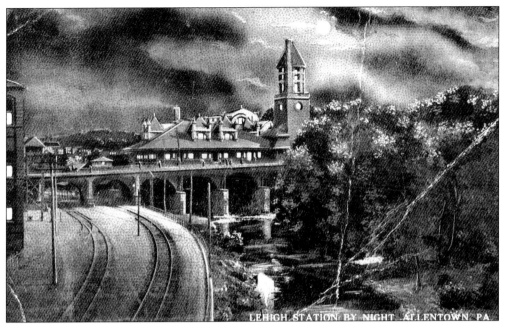

Mailed in 1914, this postcard shows a nighttime view of the Lehigh Valley Railroad Station, the tracks, and Jordan Creek. The Lehigh Valley Railroad operated the famous Black Diamond Express to cities of the northeast. Named for the company's logo, the Black Diamond was well known for reliable and luxurious service.

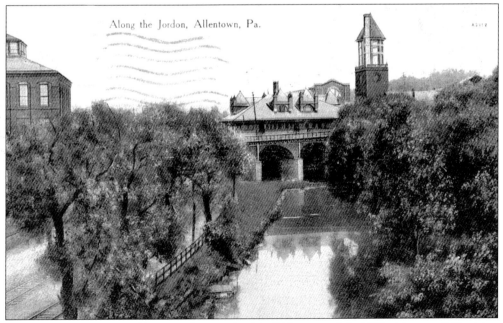

The Jordan Creek is a small, tranquil stream in this 1910 postcard. In 1933, this peaceful looking stream overflowed its banks, causing major damage to the station shown in the background.

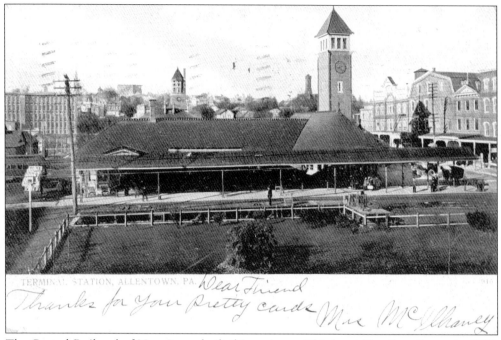

TERMINAL STATION, ALLENTOWN, PA.

Dear Friend
Thanks for your pretty cards
Mrs McElhaney

The Central Railroad of New Jersey built this station at Third and Hamilton Streets in 1890. Before this time, passengers traveling to Allentown disembarked the trains on the east side on the Lehigh River. The bell tower of the Lehigh Valley passenger station can be seen in the distance.

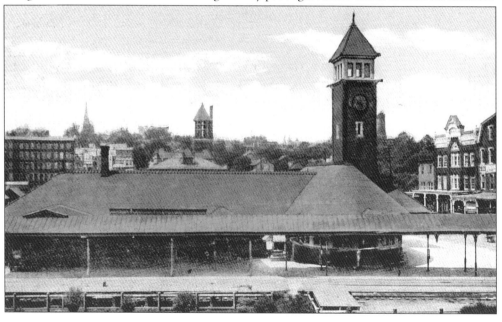

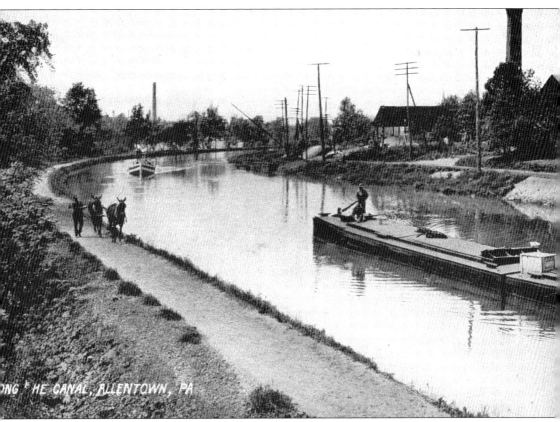

ING THE CANAL, ALLENTOWN, PA

Built to haul coal from northeast Pennsylvania, the Lehigh Canal proved a major asset to Allentown. Having ready access for transportation of raw material and finished products allowed the iron industry to build mills along the Lehigh River in Allentown. This was the start of turning Allentown into a major manufacturing city.

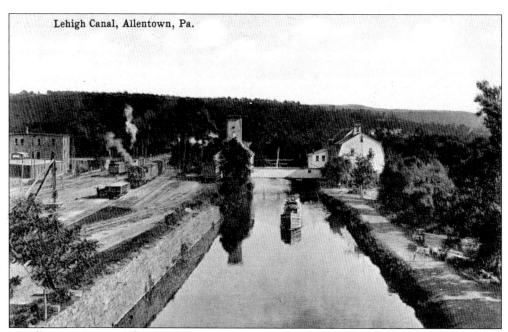

Lehigh Canal, Allentown, Pa.

This postcard captures a scene of a canal boat approaching the Hamilton Street Bridge. The building on the right of the canal was Saeger's Mill, which made use of excess water from the canal.

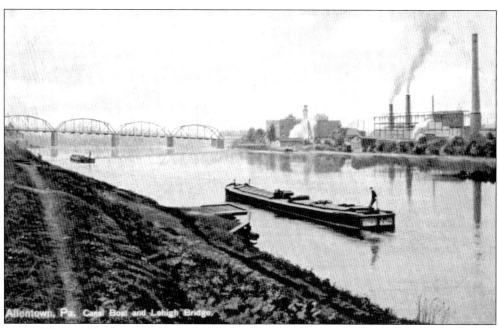

A canal boat is slowly traveling down the Lehigh River in this c. 1910 postcard. Along this portion of the canal, the boats used the river. The industrial area of Allentown can be seen on the right in this postcard. In the 1900s, this area was known as Lehigh Port.

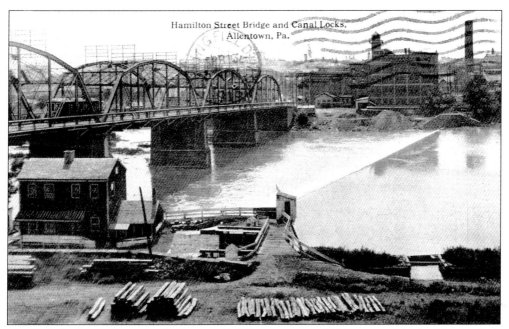

The little building shown at the bottom left-hand corner of this postcard is the lock tender's house. The Lehigh Canal had 60 locks, each operated by a lock tender that lived in a house along the canal. Also shown in this postcard is one of the eight dams built to divert river water into the canal.

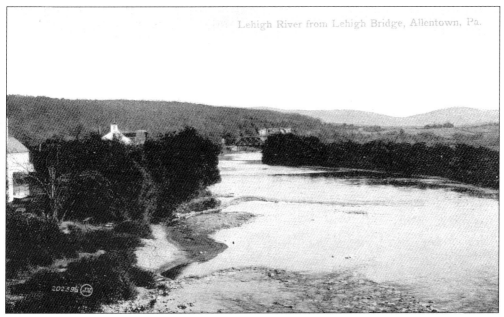

Shown in this postcard is a 1910 view of the Lehigh River south of the Hamilton Street Bridge. On the left are some of the mills located along the Lehigh Canal. Despite being a relatively small river, the Lehigh made the canal possible, which in turn bought industrialization to Allentown.

Mountain Trail near Allentown, Pa. — 7

This *c.* 1935 postcard shows an idyllic view of the Lehigh River north of Tilghman Street. Today, the Lehigh River is sometimes just a divider between the east side from the rest of the city. However, this postcard shows the river can be a thing of beauty.

MOONLIGHT ON THE LEHIGH RIVER, ALLENTOWN, PA.

Am going home on Friday

This postcard, mailed in 1906, shows a quiet, picturesque scene along the Lehigh River, only a short distance from the busy city.

Seven

THE BRIDGES
OF ALLENTOWN

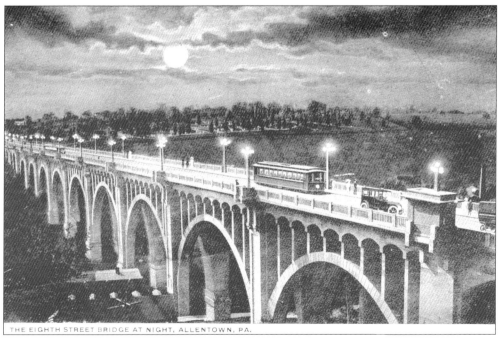

THE EIGHTH STREET BRIDGE AT NIGHT, ALLENTOWN, PA.

The Lehigh Valley Transit Company built this imposing concrete span with its massive arches in 1913. The original purpose of the bridge was to carry streetcars from downtown to the newly developing south Allentown neighborhoods.

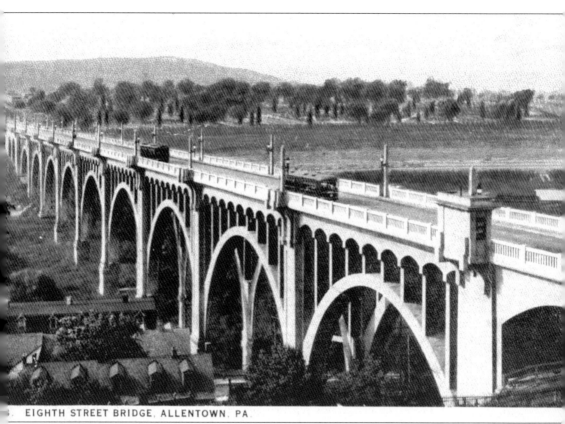

EIGHTH STREET BRIDGE, ALLENTOWN, PA

At about a half mile long, the Eighth Street Bridge was the world's longest reinforced concrete arch bridge in 1913. Pedestrians were charged a penny and vehicles 5¢ to use the bridge. The bridge towered 130 feet over the valley below.

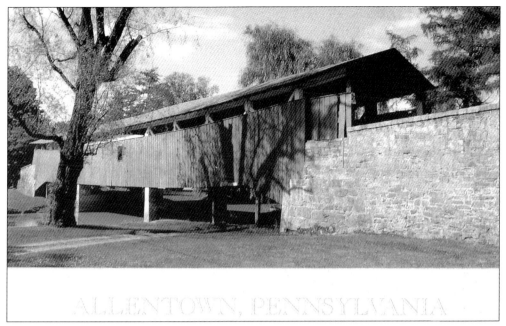

Pennsylvania was the birthplace of the covered bridge. At one time, over 1,500 covered bridges dotted the countryside of the Keystone State. As a testament to the builders' engineering skill, over 200 still stand today. The Lehigh Valley has its share of the 200, and Allentown is lucky enough to claim Bogert's Bridge, built in 1841. The oldest covered bridge in the Lehigh Valley, Bogert Bridge spans the Little Lehigh River and is 145 feet long. In 1956, a truck heavily damaged Bogert's Bridge. The bridge was repaired and reinforced by the addition of two concrete piers. The concrete supports can be seen in the top postcard. Notice the absence of the piers in the bottom postcard.

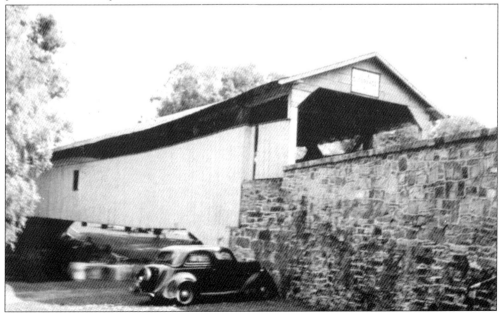

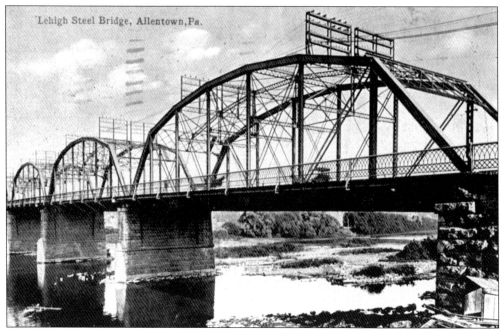

Shown above is a nice view of the fourth Hamilton Street Bridge. This bridge was completed in 1902 and lasted until 1958, when it was replaced with a concrete structure capable of handling more traffic. Note the towers at the top of the trusses that carried utility wires across the river.

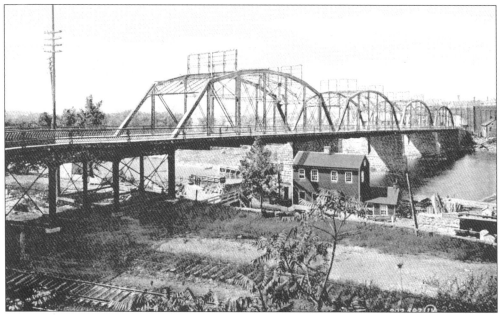

This picture shows the three different types of transportation: rail, water, and land, which were vital to helping turn Allentown into a major industrial center. In the foreground are the tracks of the Central Railroad of New Jersey. In the center of the postcard is the lock house of the Lehigh Canal. The bridge over the Lehigh River was an essential link in the turnpike that connected Allentown with the cities to the east.

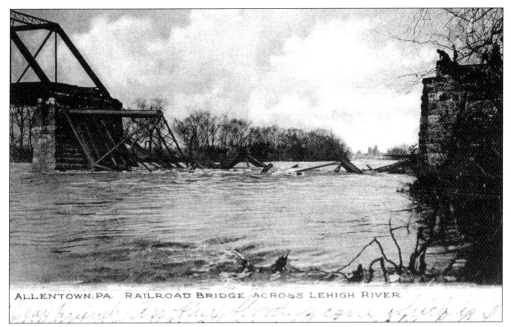

ALLENTOWN, PA. RAILROAD BRIDGE ACROSS LEHIGH RIVER.

This postcard shows the effects of the 1902 flood on the Central Railroad Bridge across the Lehigh River. The message written at the bottom of the card reads, "Dear Friend, Another flood came which is very natural."

The postcard shown here is titled "New Bridge Across the Lehigh River," and shows the repairs made by the Central Railroad. This same bridge is still in use today.

VIEW LOOKING NORTH FROM VIADUCT SHOWING LEHIGH R. R. TRACKS, ALLENTOWN, PA.

This 1906 postcard shows a horse and buggy crossing the Hamilton Street Bridge over the tranquil Jordan Creek. The tracks of the Lehigh Valley Railroad and the Adelaide Silk Mills are on the right-hand side of the postcard.

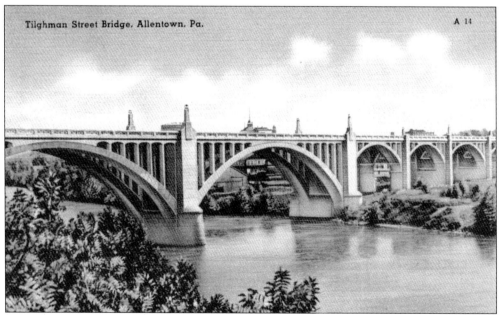

Tilghman Street Bridge, Allentown, Pa. A 14

The Tilghman Street Bridge over the Lehigh River was Allentown's first bridge built exclusively for the automobile. The engineers that designed Tilghman Street Bridge made use of massive concrete aches, reminiscent of the Eighth Street Bridge. When the Tilghman Street Bridge was competed in 1929, it opened up access to the city's east side.

Tilghman St., entering Allentown, Pa. — K-68-D-16

These two views of the Tilghman Street Bridge were taken from opposite ends. The view at top is looking west toward downtown. This postcard offers a view of the working-class neighborhoods of the sixth ward. The big building at the left of the top card is Neuweiler's brewery and the facilities of Lehigh Structural Steel can be seen at the right under the bridge. The postcard at the bottom is looking east and shows the relative emptiness of the east side around 1930.

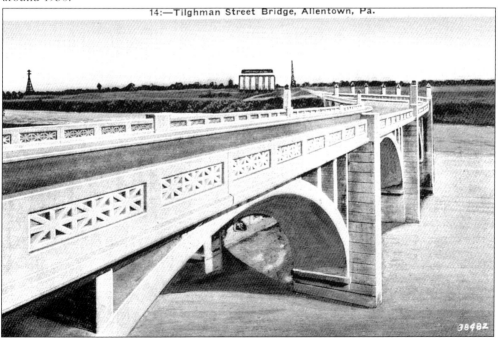

14:—Tilghman Street Bridge, Allentown, Pa.

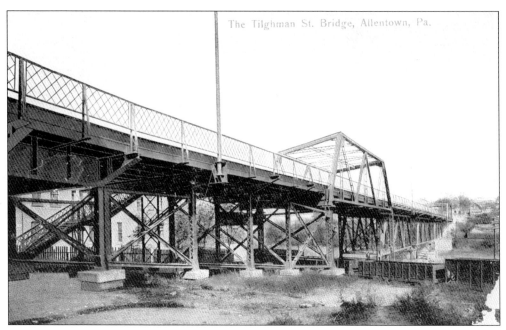

The Tilghman St. Bridge, Allentown, Pa.

In contrast to the other bridges of Allentown, the Tilghman Street Bridge over the Jordan Valley is more utilitarian in design. While the bridge may lack the aesthetics of the other bridges, it is a vital link between the city's 6th and 10th wards. This bridge was built prior to 1925 and was eventually replaced in 1987. Empty coal cars of the Lehigh Valley Railroad can be seen in the bottom postcard.

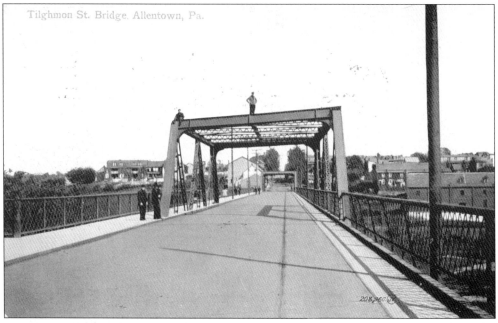

Tilghmon St. Bridge, Allentown, Pa.

Eight

PUBLIC BUILDINGS

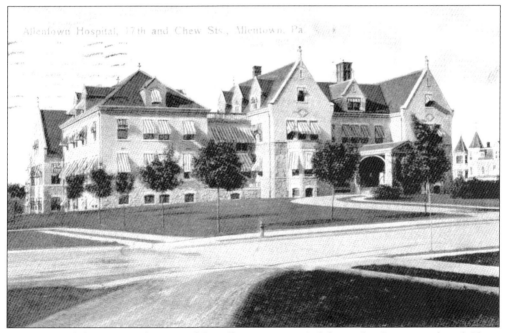

This postcard shows an early view of the Allentown Hospital, located at Seventeenth and Chew Streets. Dated 1905, this card shows the original building, which was completed in 1897. The addition was built in 1902.

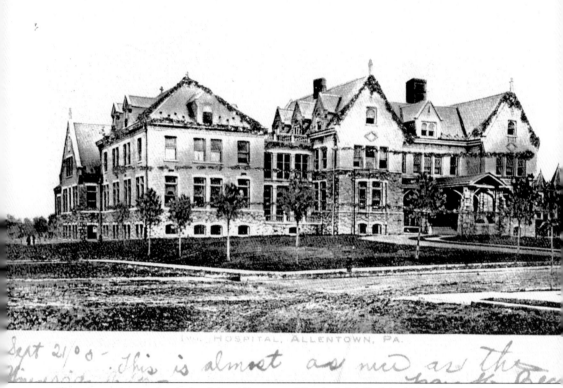

Here is another early view of the Allentown Hospital. Mailed in 1910, this card again shows the original building, along with the 1902 addition. The original building is on the right on both sides of the entrance to the hospital. Many local businessmen, including Harry Trexler and Henry Leh, provided the funding to build and equip the hospital. James Mosser funded the $40,000 addition.

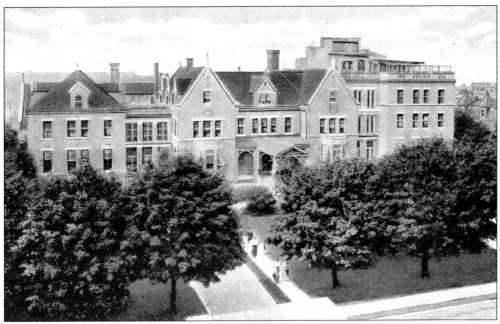

Both of these views show the Allentown Hospital with the addition built in 1912. Mailed in 1920, the postcard at top shows how high the trees grew as compared to the 1905 card on the previous page. The bottom postcard, mailed in 1945, shows how the hospital looked before further expansion occurred in the 1950s.

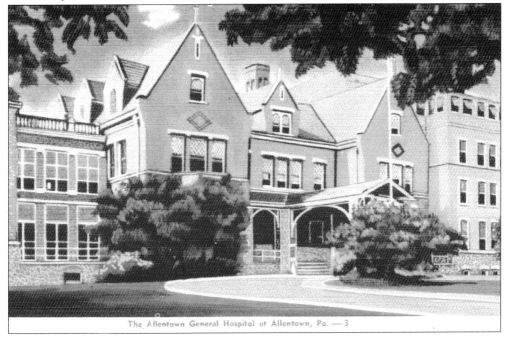

The Allentown General Hospital at Allentown, Pa. — 3

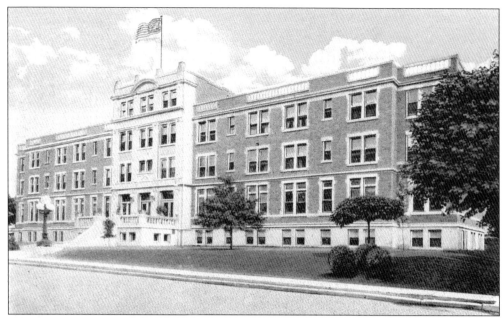

This postcard shows Allentown Hospital's Edward Harvey Memorial Nurses College. This school was named in honor of one of the founders of Sacred Heart Hospital. Before closing in 1988, the school would graduate over 5,300 nurses. Among its graduates was Anna Mae Hays (née McCabe), the first woman general in the Army's Medical Corps.

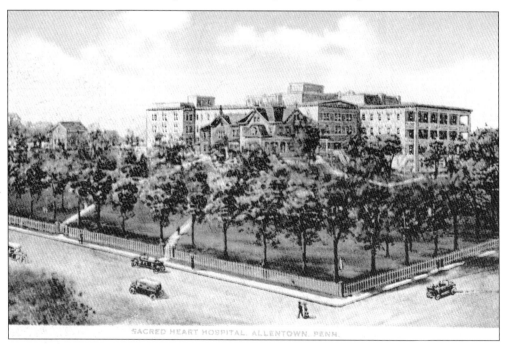

In response to a 1912 diphtheria outbreak, Msgr. Peter Masson of the Sacred Heart Parish had nuns care for patients in the church rectory on Pine Street. After the outbreak subsided, the nuns stayed on to care for patients with other illnesses. From this humble and noble beginning, Scared Heart Hospital was born.

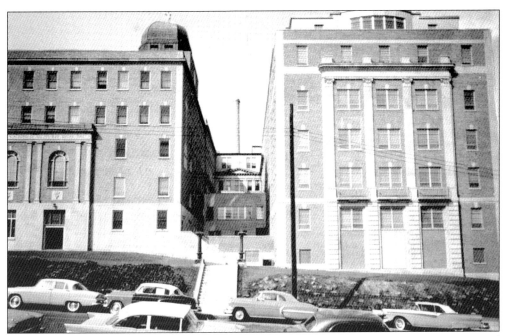

Shown above is a 1950s view of the recently completed Monsignor Masson addition to Sacred Heart Hospital. Named in honor of Sacred Heart's founder, this wing of the hospital houses a chapel and living spaces for nuns who are nurses.

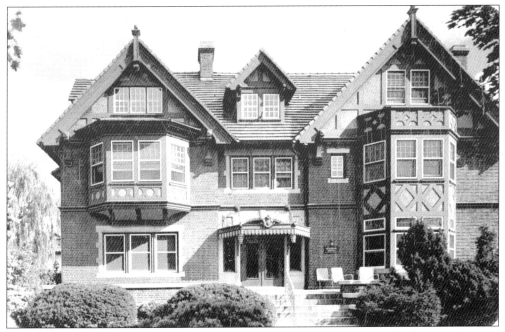

This postcard shows the original home of the Allentown Osteopathic Hospital. Allentown's newest hospital opened in 1944 in the William T. Harris Mansion located at 1746 Hamilton Street.

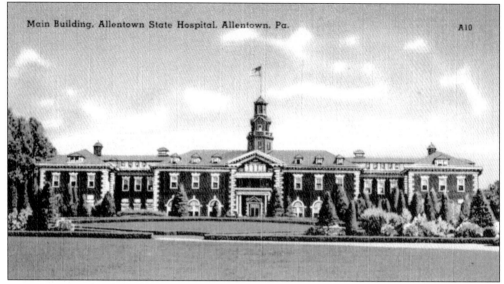

To alleviate overcrowding at other state hospitals, Pennsylvania started the construction in 1904 of a facility in East Allentown. Because of funding delays, the hospital would not be completed until 1912. Today, Allentown State Hospital occupies dozens of buildings on 206 acres of well-manicured lawns.

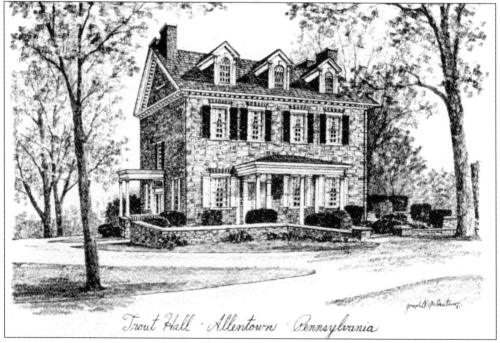

Trout Hall · Allentown · Pennsylvania

Built in 1770, Trout Hall was the home of James Allen, the son of Allentown's founder. James Allen built Trout Hall as a summer home to escape the heat and humidity of Philadelphia. Trout Hall no doubt gets its name from the abundance of fish in the nearby Lehigh River and Jordan and Little Lehigh Creeks. Today, Trout Hall is listed on the National Register of Historic places and is operated as a museum. A loyalist, James Allen would spend much of the Revolutionary War years in Trout Hall.

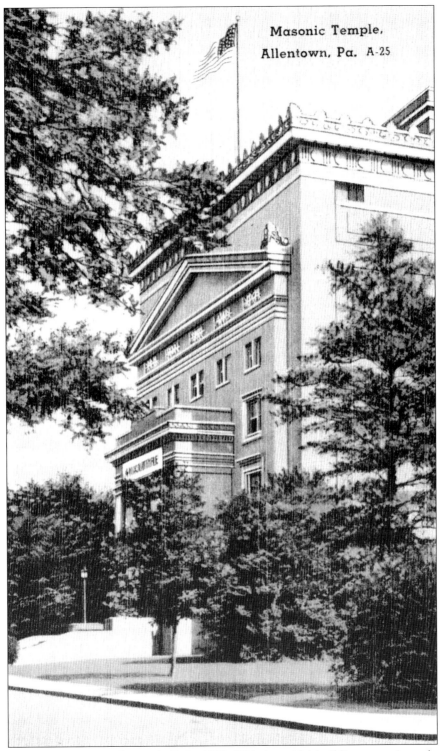

Masonic Temple,
Allentown, Pa. A-25

Allentown's Masonic temple was built in 1925. This beautiful building occupies a desirable Linden Street location directly across from West Park.

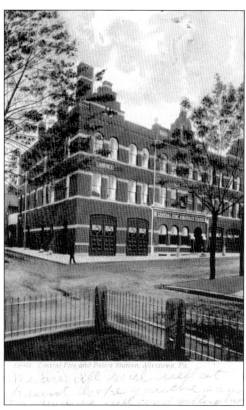

The building shown in this postcard served as Allentown's city hall from 1895 to 1962. Before this time, the city offices were located in various offices along Hamilton Street. This city hall was located at Church and Linden Streets. In 1962, the city offices moved back to Hamilton Street, but this time to a modern facility.

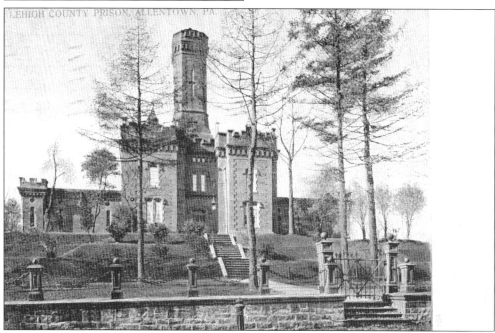

This medieval castle like structure was the prison for Lehigh County from 1868 until the 1980s. The prison was designed by Allentown's leading architect, Gustavus Adolphus Aschbach. He was also responsible for the Lehigh County Courthouse and St. John's Reformed church.

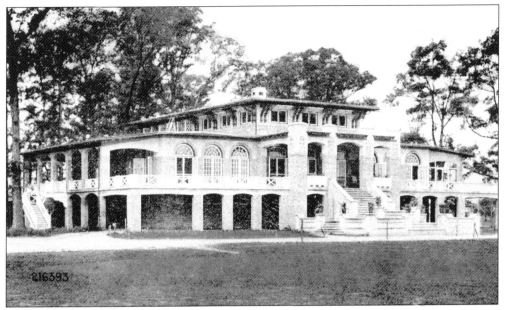

The Lehigh Country Club counted as its members many of the area's most influential people. The club opened on April 12, 1912, and operated as a club until 1928. The building burned to the ground in a spectacular 1933 fire. Today, the site is the home of a shopping center. All that remains as a reminder of the grand club is the name of the street where it was located, Club Avenue.

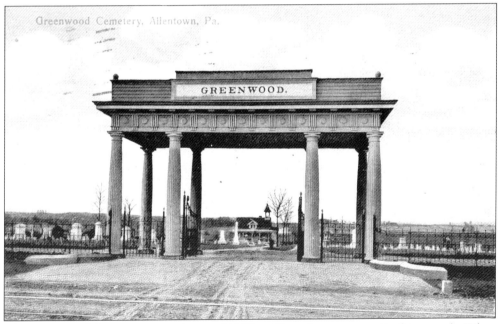

The Greenwood Cemetery opened around 1900 on Chew Street next to the fairgrounds. When it opened, Greenwood Cemetery was located in what was considered countryside.

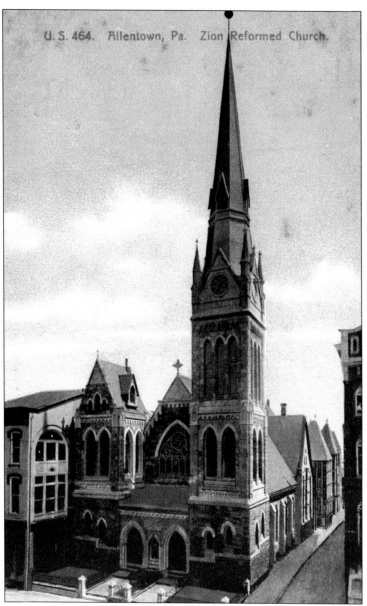

U.S. 464. Allentown, Pa. Zion Reformed Church.

As Allentown's most historic church, Zion Reformed Church can date its history back to 1747, 29 years before the birth of the nation. The congregation of Zion Reformed Church concealed the Liberty Bell from the British during their occupation of Philadelphia. This was done at great peril to themselves. If the British found the bell, the people responsible could be arrested as traitors. The church building also served as a hospital for wounded Revolutionary War soldiers. The congregation opened its first house of worship in 1762 after a delay caused by the French and Indian War. Before that time, services were held in private houses, barns, and in the open. In 1770, William Penn gave permission for a lottery to be conducted, the purpose of which was to raise funds for a second church building. The construction of this church started in June 1773, and was finished in 1776. It was in this stone building that the Liberty Bell was hidden from the British from September 1777, until October 1778. A third church was built in 1840 to be eventually replaced by the attractive gothic building shown above in 1888.

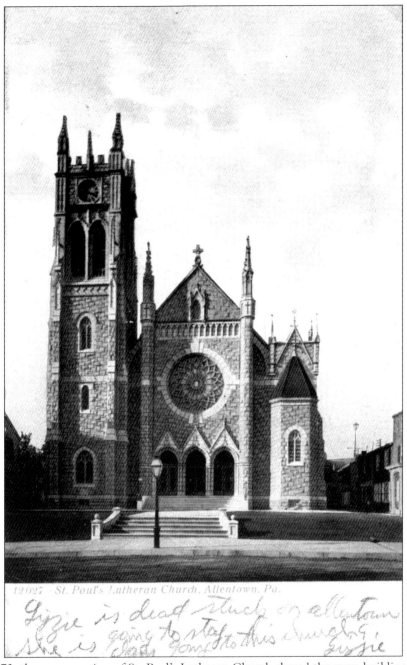

12 027 — St. Paul's Lutheran Church, Allentown, Pa.

Lizzie is dead stuck on allentown she is going to stay this summer. Lizzie

Until 1773, the congregation of St. Paul's Lutheran Church shared the same building as Zion Reformed Church, then known as the German Reformed Church. The church's enrollment grew considerably in the period after the Revolutionary War. To better serve its members, a new church was built on South Eighth Street on land donated by Mrs. William (Allen) Tilghman. Mrs. Tilghman was the granddaughter of William Allen, the city's founder. She is buried in the basement of the church. St. Paul's used the German language in its services well into the late 1800s. Today, St. Paul's continues this tradition of ministering to immigrants by holding some its services in Spanish.

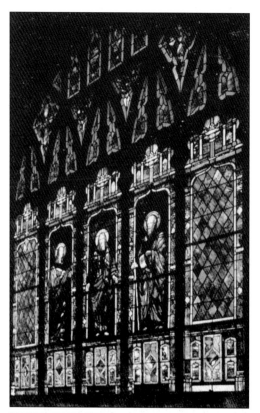

Pictured here are two postcards of the beautiful Christ Lutheran Church located at 1245 Hamilton Street. Christ Lutheran began its mission in 1903 to serve the expanding population of the city's west side. The impressive and decorative stained glass window was presented to the congregation in memory of Frank Koch by his wife and their daughter, Mrs. Norton Lictenwalner. The second picture, taken in the late 1950s, shows that the exterior of Christ Lutheran Church is as beautiful as the interior. The impressive original 1903 building is shown on the left. On the right-hand side is the equally impressive education building, erected in 1936. The education building houses the church offices and a gymnasium, along with classrooms. Over the last 100 years, the church has prospered at this prime location and today draws members from all over the Lehigh Valley.

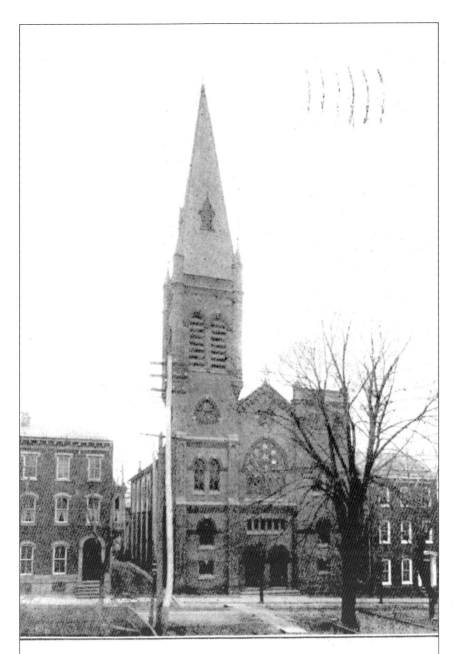

St. John's Evangelical Lutheran Church
Allentown, Pa.

St. John's Lutheran located on South Fifth Street is one of Allentown's oldest institutions. Founded by Christian Pretz in the 1850s, St. John's Lutheran was the city's first English-speaking Lutheran congregation. The church building, as shown in this postcard, was replaced in the 1930s with a bigger and better church. The Rev. William C. Schaffer dedicated the new church on September 22, 1939.

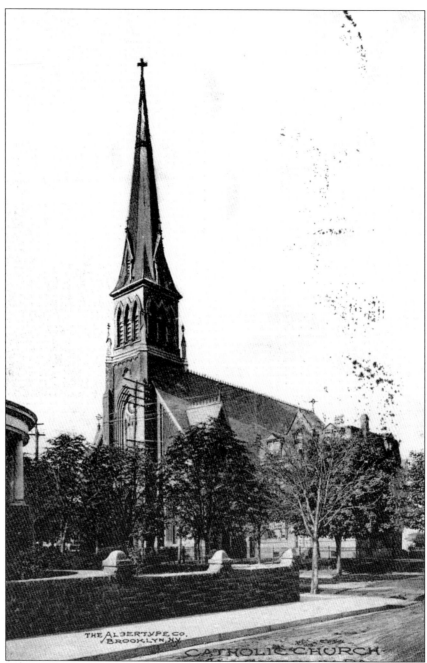

THE ALBERTYPE CO.
BROOKLYN, N.Y.

CATHOLIC CHURCH

Founded in 1856, Immaculate Conception was the city's first Catholic parish. Construction of the church, as shown in these postcards, started in 1873, and it was dedicated in 1881. The first church members were a mix of Irish and German immigrants who came to work in the mills and factories along the Lehigh River. The period immediately after the Civil War was a prosperous time in Allentown and Immaculate Conception grew in membership. However, the German parishioners wishing to hear their language during the services left and formed Sacred Heart Catholic. Thereafter, for generations Immaculate Conception was referred to as the English Church and Sacred Heart as the German Church.

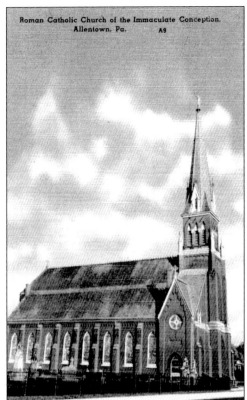

Roman Catholic Church of the Immaculate Conception.
Allentown, Pa. A9

These two postcards show Immaculate Conception as it looked around 1905. This Ridge Avenue church was first named St. Mary's. The name was changed to Immaculate Conception in 1873. The title on the bottom postcard refers to the "English Cemetery," as compared to the German church, or Scared Heart.

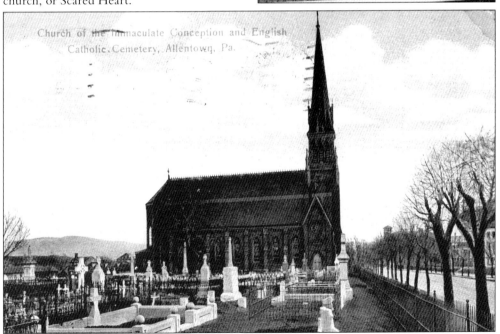

Church of the Immaculate Conception and English Catholic Cemetery, Allentown, Pa.

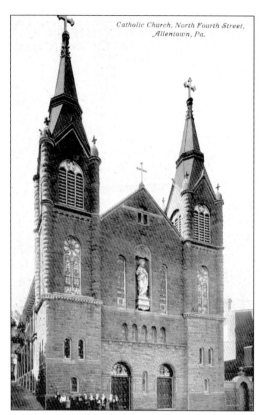

Catholic Church, North Fourth Street, Allentown, Pa.

The postcard on the left shows a view of Sacred Heart Church as it appeared in 1913. The bottom postcard was mailed in 1935. Both of these pictures show that the congregation took great pride in creating a beautiful place to worship.

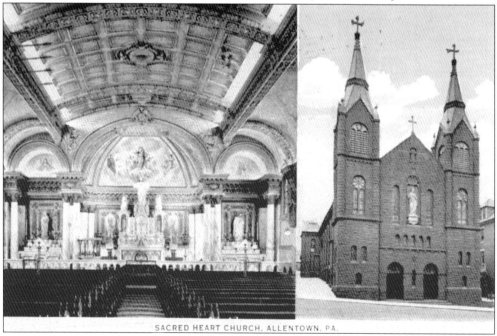

SACRED HEART CHURCH, ALLENTOWN, PA.

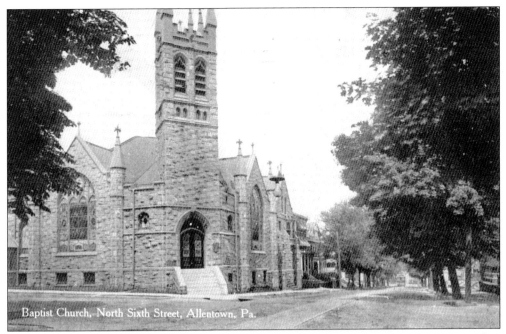

Located at 302 North Sixth Street, Allentown's first Baptist church traces its roots back before the Civil War. The church's first building was dedicated on November 11, 1867.

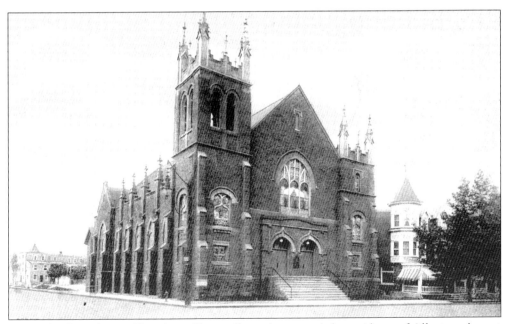

St. Stephen's Lutheran Church on Turner Street has served the residents of Allentown's west side for over 125 years.

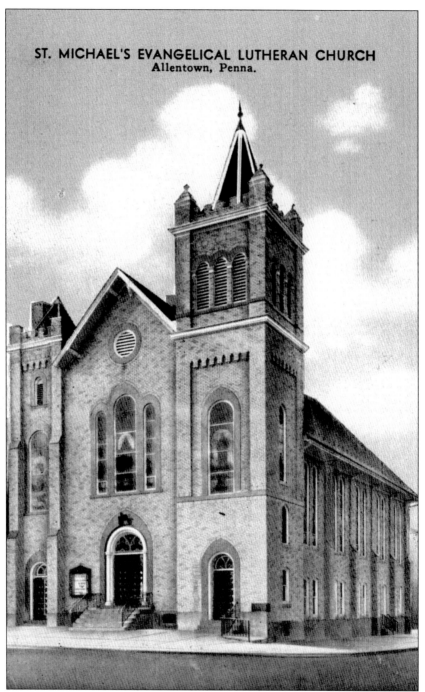

ST. MICHAEL'S EVANGELICAL LUTHERAN CHURCH
Allentown, Penna.

St. Michael's Lutheran Church formed as a result of a dispute in another church. In the early 1870s, the congregation of St. Paul's was in turmoil. A dispute erupted over two issues. One was whether to use German or English during the services. The other was over the ministerial style of Reverend Mening. To provide a place for the children free from conflict, a new Sunday school started in a fourth ward school. This Sunday school would eventually become St. Michael's.

First Presbyterian Church,
Allentown, Pa

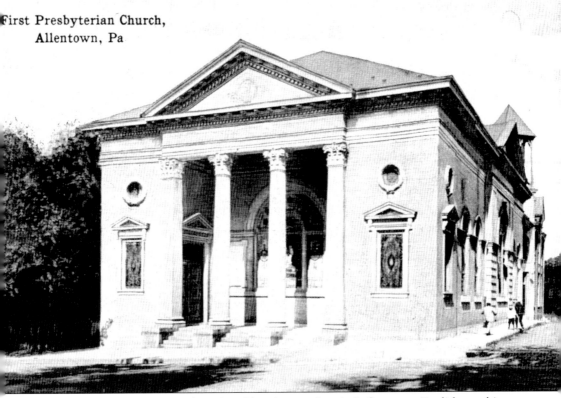

Formed in the 1830s, First Presbyterian Church was the city's first true English-speaking church. It was also one of the first churches in Allentown to have a full-time pastor. Built in 1902, the church, as pictured here, was actually the congregation's third building. In the 1950s, First Presbyterian moved to a new building on Cedar Crest Boulevard. The old church building, shown in this postcard, became the new Allentown Art Museum.

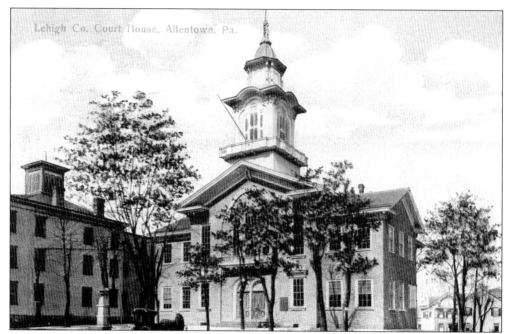

Built in 1819, the Lehigh County Courthouse was designed by Allentown's leading architect, Gustavus Adolphus Aschbach. The courthouse underwent a major renovation in 1864. In this renovation, the façade and interior were restructured and improved. In addition, a much larger cupola was placed on the building. The bottom postcard shows the addition that was built in 1915. In a twist of irony, destructive World War I saved the courthouse from ruin. In June 1917, plans were approved to tear down the old courthouse and expand the newly completed addition. Labor and material shortages caused by the war made this impossible. Fortunately for the people of Allentown, the project was cancelled.

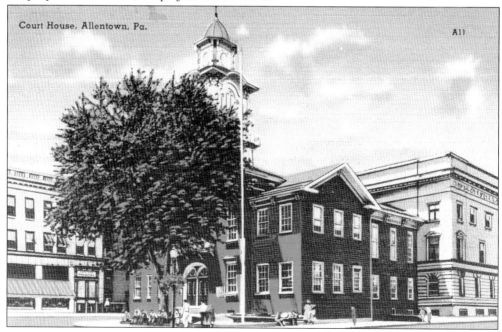

Court House, Allentown, Pa. A11

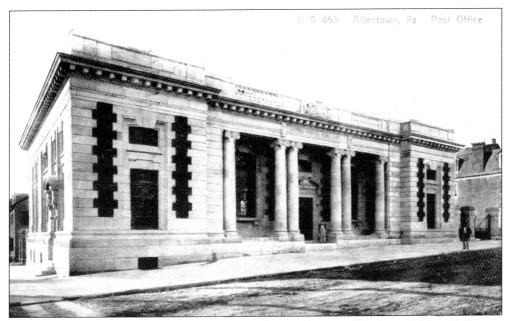

The building shown in this postcard served as Allentown's post office from 1904 to 1933.

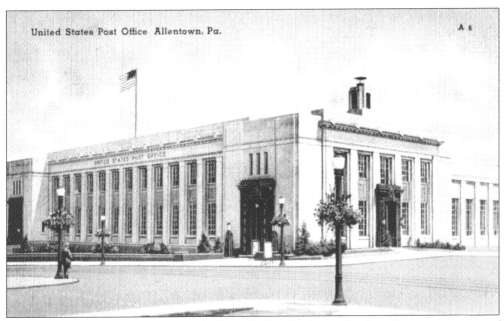

Allentown's current post office was built in 1933. The impressive building gives a sense of elegance and style to downtown Allentown.

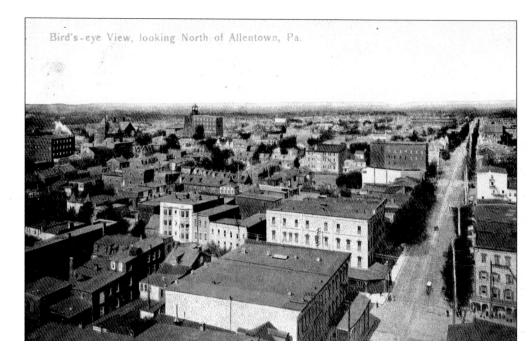

These two postcards show how much Allentown grew as a city during the 1900s. The top postcard was mailed in 1910, and the bottom card is a 1972 picture. The picture on the older card was taken from the National Bank Building and shows North Seventh Street. The newer card shows downtown, and the first, fifth, sixth, and ninth wards, along with the city's east side off in the distance.

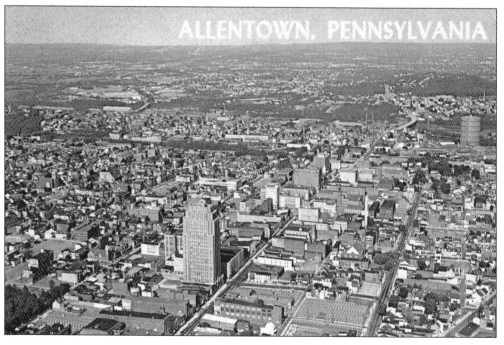

120

Nine

PREPARING FOR WAR

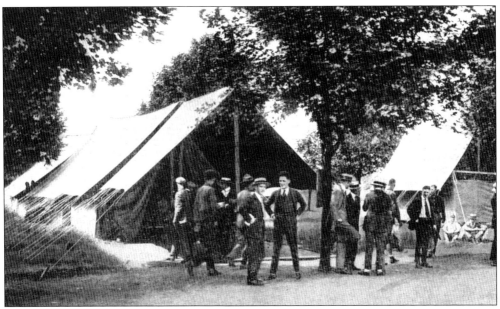

During World War I, the Allentown Fair Grounds was a site for training men to serve in the Army's Ambulance Corps. The men's first taste of army life was in the examination tents located at the entrance to the fairgrounds. Here they would receive their required vaccinations and shots. Men enlisted in the Ambulance Corps from all over the country. Many of the nation's elite universities formed complete companies and sent them off to Allentown for training.

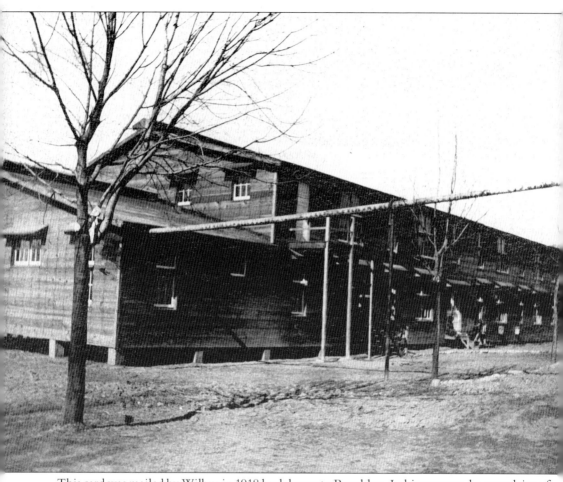

This card was mailed by Wilbur in 1918 back home to Brooklyn. In his message, he complains of the drafty windows. Wilbur was luckier than the earlier trainees because by 1918, the building was equipped with steam heat via the pipe shown in the middle of the picture.

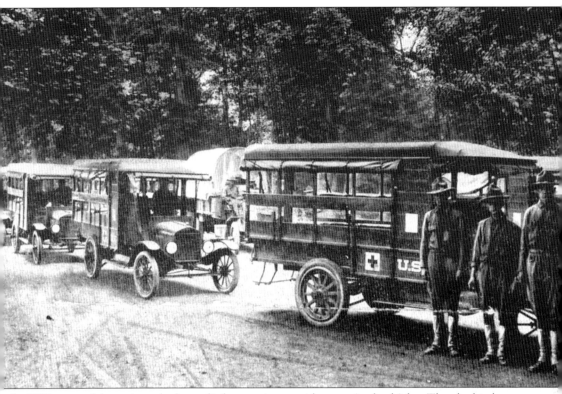

In 1917, most of the trainees had very little experience with motorized vehicles. They had to be taught the basics of how to drive and care for the new Ford ambulances.

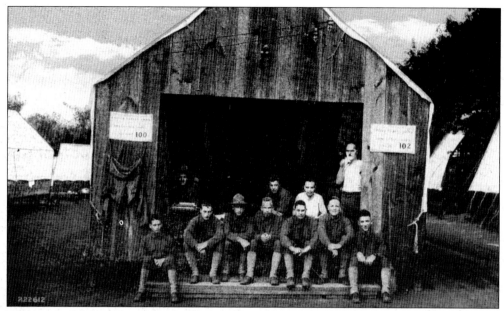

The men on this card are shown relaxing outside their barracks. To occupy the men's spare time, the army formed baseball and football teams. The opponents included many of the local colleges, including Penn State. At one time or another, the Cramp Crane football team boasted 15 College All-Americans.

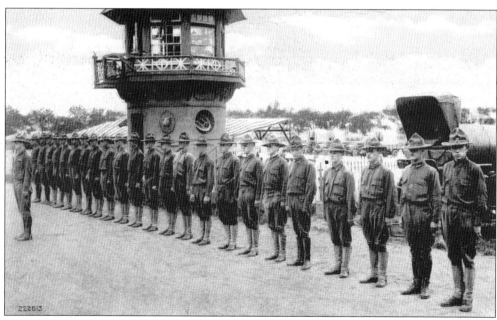

Here, the men are standing in formation on the racetrack. Before and after the war, the racetrack was used during fair week for horse racing. The tower in the background marked the finish line for the horse races.

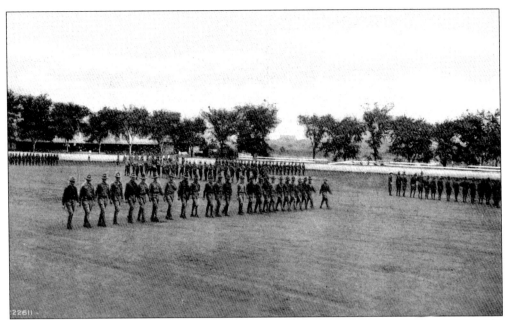

Before the men could learn how to be medics and ambulance drivers, they had to learn to be soldiers. Here, the men are learning how to drill and march, using the fairground's racetrack. The half-mile racetrack made an excellent marching surface. Besides the racetrack, the men often marched through the streets of Allentown and even into the countryside.

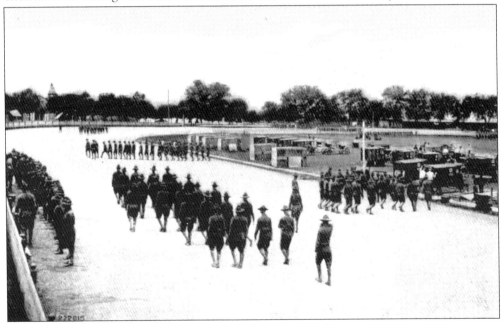

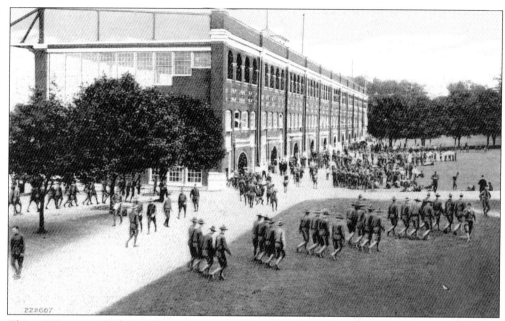

This 1918 postcard shows the trainees marching on the grass-covered fairgrounds. In the background is the relatively new grandstand. In the beginning days of Camp Crane, the last rows of the grandstand were removed to make way for additional sleeping space.

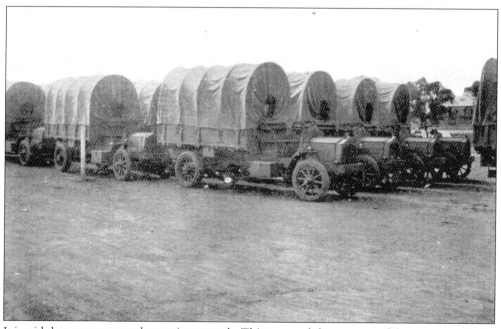

It is said that an army marches on its stomach. This postcard shows some of the many trucks the Ambulance Corps used to transport their food and other supplies.

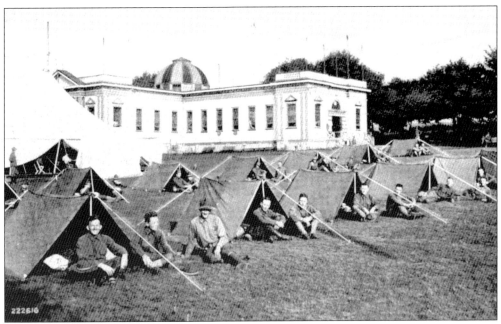

The top postcard shows men proudly posing in front of their pup tents. The postcard on the bottom shows the men hard at work marching on the infield of the racetrack. In spite of all the hard work, the trainees did have free time. To entertain themselves, the men put on plays and vaudeville acts. These performances became so popular that they were moved to downtown theaters so the town people could also attend. Both Dorney and Central Parks sponsored outings for the men. They must have had a good time at the parks because it was necessary to have the Provost guards tag along to keep order.

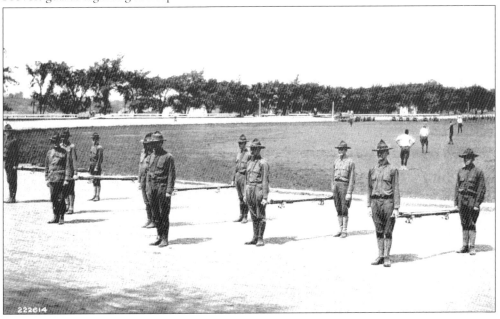

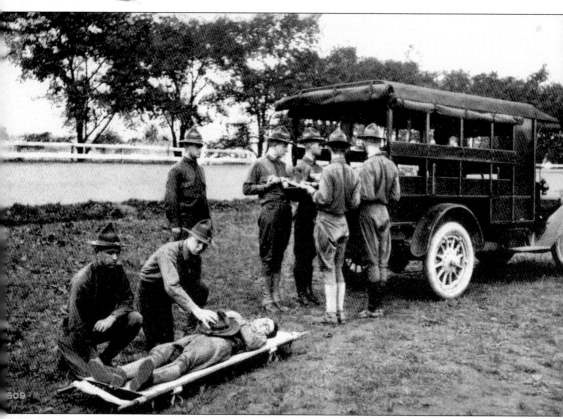

This postcard is a vivid reminder that preparation for war is serious business. Sadly, the U.S. Army Ambulance Corp lost 471 men in Europe. In addition, 320 men were wounded and 40 were taken prisoner. By all accounts, the men of the Army Ambulance Corp served proudly, earning over 1,300 medals and citations.